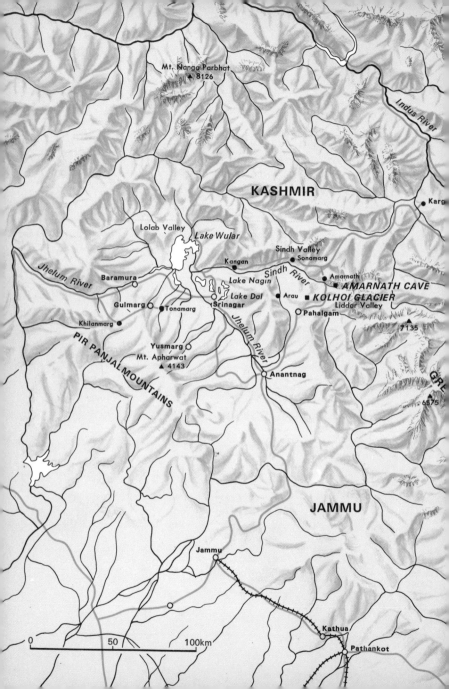

Kashmir

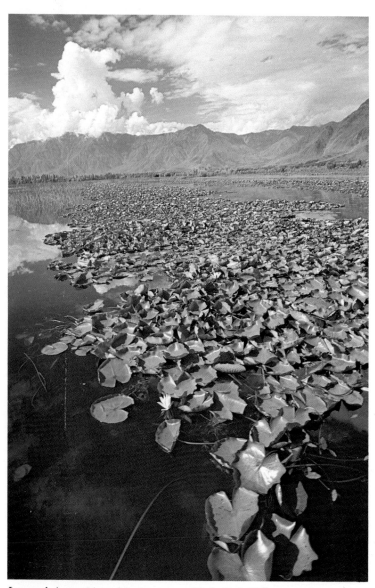

Lotuses being cultivated in the center of Lake Dal. The roots and seeds are a staple food among the people in the area.

Kashmir

SHINYA FUJIWARA

Translated by Margaret F. Breer

KODANSHA INTERNATIONAL LTD.
TOKYO, NEW YORK & SAN FRANCISCO

Distributors:

UNITED STATES: *Kodansha International/USA, Ltd., through Harper & Row, Publishers, Inc., 10 East 53rd Street, New York, New York 10022.* SOUTH AMERICA: *Harper & Row, Publishers, Inc., International Department.* CANADA: *Fitzhenry & Whiteside Limited, 150 Lesmill Road, Don Mills, Ontario.* MEXICO AND CENTRAL AMERICA: *HARLA S.A. de C. V., Apartado 30–546, Mexico 4, D. F.* UNITED KINGDOM: *Phaidon Press Limited, Littlegate House, St. Ebbe's Street, Oxford OX1 1SQ.* EUROPE: *Boxerbooks Inc., Limmatstrasse 111, 8031 Zurich.* AUSTRALIA AND NEW ZEALAND: *Book Wise (Australia) Pty. Ltd., 104–8 Sussex Street, Sydney 2000.* THE FAR EAST: *Toppan Company (S) Pte. Ltd., Box 22 Jurong Town Post Office, Jurong, Singapore 22.*

Published by Kodansha International Ltd., 2-12-21 Otowa, Bunkyo-ku, Tokyo 112 and Kodansha International/USA, Ltd., 10 East 53rd Street, New York, New York 10022 and 44 Montgomery Street, San Francisco, California 94104. Copyright © 1977 by Kodansha International Ltd. All rights reserved. Printed in Japan.

LCC 77–75973
ISBN 0–87011–310–0
JBC 0326–785965–2361

First edition, 1978

Contents

Drawings by Shinya Fujiwara

Impressions of an Emerald City

Because of continuous trouble with the bus, it was already two and a half hours after nightfall by the time I neared Kashmir's capital city of Srinagar. I came expressly to visit this city, and now that I was at last drawing near, I could hardly contain my excitement. Even though it was dark, my first impressions were very vivid.

While still on the bus, my skin actually registered the change. Travelling in May from the scorching heat of India's plains to the highland basin of Kashmir was indeed an escape from Hell's inferno to the cool breezes of Paradise. There was also a distinct difference in smell. After the parched dry heat of Central India in summer, I welcomed the fresh moist fragrance of Kashmir's trees, flowers and grass.

I could not resist tapping the shoulder of the middle-aged Indian man who was sitting next to me on the bus and remarking: "Kashmir is just as magnificent as I had heard." He was a jewel broker from a town near the desert in the state of Rajasthan and had with him a large metal case full of garnet chips. It was his first visit to Kashmir and after such a tiring trip, he had dozed off and only half heard my remark. Yet when he realized that we had arrived in Kashmir, he opened his tired eyes and stared out into the darkness. After several minutes he turned from

the window and half mumbled to himself: "Well, I'll have to have a good look in the morning—I really can't say anything yet." His reactions were not as immediate and positive as mine.

This well-known place which we had reached in darkness was to prove to be single huge emerald of a city. Quite naturally it was meant to be seen in morning light—most ideally in the pale of early dawn.

Being rather tired from the long trip and by nature a late riser, I decided to sleep in that first morning in Srinagar and not get up until just before lunch time. I can scarcely remember having ever gotten out of bed before sunrise, but the next day I was surprised to find myself awake at an amazingly early hour.

I found and recommend that one of the best ways for a visitor to Kashmir to gain an understanding of the place is to sharpen one's sense of hearing. Every morning strange and unfamiliar sounds float through the air. Almost like a stage production, the curtain of night is pulled away each day in Kashmir with musical accompaniment. One might assume that I am referring to the many birds which gather and sing in the trees every morning. This is not altogether wrong, but the song which I mention here is one sung by humans. In fact, it almost seems as if the birds and other beasts are awakened by man and then hasten to accompany him in song.

When I woke, I could faintly distinguish the sounds of someone singing, yet my watch told me it was before 5:00 A.M. Looking out the window I saw that the sky was a deep blue and there were even a few stars still twinkling in the western sky. Seeing the stars I thought, "Oh, no! Look what I've done!" Had I been so exhausted that I slept right through my first day here and only now opened my eyes?

Just as I started to leap out of bed, the song which I thought I had heard in a dream again floated across the deep blue sky

still twinkling with morning stars.

> Allahu Akbar
> Allahu Akbar
> Allahu Akbar
> Allahu Akbar
> Ash hadu Alla-ilahu illa-lah
> Ash hadu Alla-ilaha illa-lah
> Ashhadu Anna Muhammadar Rasu lul-lah
> Ashhadu Anna Muhammadar Rasu lul-lah
> Hayya-Alal-Salah
> Hayya-Alal-Salah
> Hayya-Alal-Falah
> Hayya-Alal-Falah
> Allahu Akbar
> Allahu Akbar
> La-ilaha illal-lah

This song is the *Azan* and in Muslim countries it is sung five times a day calling the people to prayer. In English, the words mean:

> God is great
> There is no God but God
> Mohammed is a messenger of God
> I bear it witness
> I bear it
> God is great
> There is no God but God

These words were sung by a strong quivering masculine voice and sounded strange to my ears, the ears of a foreigner. But the spiritual intonation might cause one to feel that long ago, when still in the womb, one heard these sounds together with the mother's heart beat.

This was my first visit to a Muslim country so I was initially not aware of the significance of this sung prayer. Any visitor who has been in other areas where Muslims live would know immediately the tones of the sacred *Azan*.

This early morning song reminded me of visiting Catholic countries and hearing the peel of bells from cathedral towers. It also called up feelings such as I have when I hear the deep heavy toll of a temple bell which creeps out over the town in Buddhist countries. In Lamaist areas such as Kashmir's northern section of Ladakh, three monks appear on temple verandahs early each morning and blow their enormous horns. The blasts which resound from the hilltops sound like the snorting of dragons.

Five times each day of my stay in Srinagar, I heard the sacred pledge to Allah chanted by specially trained voices. The melodious words reached out to the faithful from four speakers affixed to the tower of every temple. In the early morning I could hear them from far and near, like the trolling of several singers. The sounds became entwined as if one voice were reaching out to Allah and echoing back from the Karakoram Mountains to the north.

I came to enjoy waking up to the beautiful sounds of the *Azan* and it became a delightful custom with me to lie in bed every morning dreamily listening to the words of this song. After a while I began to notice the curious tones of yet another song. Hearing this second song after the *Azan* always cheered me. It came from the stray dogs which roam this emerald city. Even these dogs must have felt the force of the morning prayer for they seemed to be singing the *Azan*. The first few times I heard this far away howling, I did not know what it was. By the third or fourth day, however, I was sure that the dogs were calling in response to the people. It then seemed rather comical, and as I lay in bed I could

hardly contain my laughter. Yet listening to this wordless song day after day, it began to sound just as devout a prayer as the real *Azan* and I was moved almost to tears. I should probably not even have written about being impressed by the distant howling of stray dogs, yet any tourist in Kashmir who fancies the unusual should listen for this wordless *Azan*. It made me vividly aware that religion in Kashmir governs not only man, but all living creatures right down to the smallest insect.

A professional singer of the *Azan* hearing me say this would surely be shocked and would tell me in no uncertain terms that it is definitely not the *Azan* but just the noise of dogs barking. To someone like me, however, unfamiliar with the Muslim religion, the distant howling of the stray dogs sounded just like the real *Azan*.

As I lay in bed each morning gazing out into the dark sky and listening to the beautiful words of the *Azan*, I began to feel that they did indeed signify the very power of nature—the force above and beyond the capacities of mankind. Then I would listen for the dogs. Apart from the ordinary barking heard throughout the day, at least once every few days—or with luck, several days in succession—I would hear the distant howling as it faded away like the lingering wail of a siren. I was convinced that the dogs were imitating the *Azan* they heard sung by humans. Here, one force shapes all of life, and all creatures enjoy the same gifts of nature whether they be swimming in the lakes, chirping in the trees, flying in the sky or sleeping under the eaves of the town's houses. I began to understand that I too had a place in this scheme and that I was being absorbed in the green jewel called Kashmir.

The proprietor of my hotel was a man of about fifty who always wore a Kashmir hat. Although he did not go so far as to sing the *Azan* himself, he was quite a religious person and rose each morning twenty or thirty minutes before the *Azan* first

sounded across the dark sky. In the middle of his garden which abounded with maidenhair ferns, he would prepare himself for prayer by laying out a small Kashmir carpet. This was a special carpet used only for prayers and he knelt on it five times every day. I lay in bed in the mornings and watched him through the window of my second-floor room. After a few days, as he rolled up his carpet after prayer, I commented on his devoutness. "What a deeply religious man you are. Day after day you come out to pray so early in the morning. In my country only the priests show such devotion." Pausing with the rolled up carpet under his arm, he replied: "I am not the only one who is religious. Here in Kashmir, everyone gets up early.While the *Azan* is recited, many people are in the temples saying their prayers.We believe that anyone who stays in bed when he hears the *Azan* will receive only half the profit of Allah's blessing." What I intended as a compliment thus resulted in my being reprimanded for sleeping late in the morning.

Kashimiris do rise early; this does not always mean, however, that they work hard all day long. The religious zeal of the servant in the house next door to my hotel was such that he would leap up and pray every time he heard the *Azan*. The rest of the day he dozed in the corner of the house hardly working at all. The number of other Kashmiris similarly employed led me to suspect that when my hotel keeper referred to profit, he did not mean it in the monetary sense of the word.

And, truly, the benefits gained from waking early in Kashmir are beyond monetary or bodily gain. The greatest of these is the enjoyment of Kashmir's magnificent scenery in the early morning. Kashmir is blessed by nature at any hour of the day—from the time the sun begins to rise in the eastern sky as the *Azan* is first sung, until it turns red again in the evening. Above all, however, I prefer the quiet of Srinagar at dawn.

After I became accustomed to life in Srinagar, I would often treat myself to the inexpensive luxury of going out on the lakes in a small boat and enoying a light breakfast as the first rays of morning sun began to strike the water. The inexpensive little boats are called *shikara* and are rather like water taxis. They are quite comfortable—almost like floating sofas—and I found them to be a very beautiful and pleasant mode of transportation.Whenever I hired one, I could float for several enjoyable hours along the lakes or many canals.

The surface of the water in the canals is covered with little green plants that are slowly parted by the prow of the boat as it moves along. Both banks of the canal are luxuriant with poplar and willow trees, and in some places they are so thick that they meet overhead, almost hiding the sky from view. In places the sunshine pierces through the trees and makes the peaceful green tunnel all the more beautiful.

Floating along amidst the tranquil fragrance of the foliage, earth and water, I would notice an occasional small spray of water about ten meters in front of the boat. At first I thought it was a fish jumping out of the water but upon closer inspection I found not a fish but a small bird which was catching fish. This little creature is called a fishing bird and is amazingly quick. Catching a glimpse of this bird with its bright blue feathers is another pleasure to look forward to when one takes an outing on the canals. Sometimes, on slightly chilly mornings, the surface of the water would be enveloped in mist. Although I could not see the fishing birds through the mist, I could hear them chirping as they sought their prey.

It often happened that as I was listening to the birds, a boat full of local people whose home was on the water would suddenly appear out of the fog and pass by in the other direction. I might be stretched out half asleep on the sofa of my *shikara*, but I always

sat up quickly to have a good look at the inhabitants of the boat. Even if the boat were not the least bit beautiful, one never knew when a surprisingly beautiful Kashmiri girl would be skillfully sculling the boat. She might have a slender body, white skin and beautifully shaped nose. Her eyelashes and eyebrows would be thick and her eyes as clear and liquid as the deep water, a reflection, perhaps, of the fact that she was always on the water. Even though such a beauty might come within a meter of my boat as we passed on this fragrant canal, had I been dozing, I would have missed the chance to see her in her colorful Kashmir dress. A great visual opportunity would have slipped by unheeded. Seeing such a vision, I would smile to myself and wonder if this were one of the benefits sung about in the *Azan*. At least, I would be grateful to the Kashmir beauty who afforded me the treat. A true Kashmir beauty, however, would never allow her eyes to meet mine. Properly, she would lower her gaze and appear a bit flustered as she disappeared into the fog.

I must add that when you are out enjoying yourself on the water, there are other people around besides the Kashmir beauties. I recall once waiting excitedly as I saw a boat coming my way. Imagine my disappointment when I discovered not a young Kashmiri beauty but a large man rowing towards me with such incredible speed that he set my boat rocking. Some men like this one are persistent in coming over to your boat and dissipating the lazy, tranquil atmosphere of these early morning rides. They are Kashmir's well-known peddlers, and any visitor ought to learn something about them. They not only seek out customers in the towns but pursue them on the lakes, rivers, and canals. Anyone looking the least like a tourist will be approached by these peddlers twenty or thirty times a day. I found this particularly striking as it contrasts with the customs of my own country, where peddlers may come to one's house to sell their

wares, but do not approach people on the street.

About the third day after my arrival in Srinagar, I found myself so surrounded by peddlers that I thought of engaging a *shikara* to go out on the lake for some quiet time alone. On the lake, however, what did I find but a man following me. He looked just like the man who had been selling the very same wares on shore earlier. I was so amazed at his determination that I bought a small wooden box from him.

When I returned to shore, this man again approached me and tried to sell me a wood carving. I was a bit irritated and spoke to him rather sharply, "Didn't I just buy something from you?" He asked what sort of man had sold me the box, and I replied, "His face looks just like yours." The man exclaimed delightedly, "Oh! That must have been my younger brother!" It appeared that the entire family was out selling the same line of products. This man seemed to sense my desire to be left alone and went away, but was back again in no time. "Since you bought a small box from my brother," he announced as if we were on the friendliest of terms, "then why don't you buy a bigger box from me in which to keep it!"

The list of items to buy in Kashmir includes wood carvings, carpets, shawls, papier-mâché, furs, jewels, honey, antiques, saffron, and engraved silver. Most merchants are plying their trade from small shops, but there are quite a few who approach likely customers at their hotels, on their houseboats, and in *shikaras*. Wherever one looks, enterprising peddlers bustle about.

One tourist bought a spotted lynx fur coat at ten times the usual price. A careful traveler wishing to purchase the many lovely and unique items sold on Kashmir streets should be well informed as to price. Authenticity, too, should be confirmed. In the case of furs, particularly, it is sometimes difficult to distinquish the real from the man-made.

I was making an extended visit to Kashmir. After a month I grew rather exasperated at still being pursued by peddlers all through the town and over the waterways and gave serious thought to how I might take excursions in peace and quiet. Finally, I decided to go out in shabby clothes to present a less affluent appearance. This scheme was a great success. When I strolled about in wrinkled shirt and worn-out trousers, carrying my camera and other belongings in an old cloth bag, the town responded very differently. With a look of resignation, merchants just watched me pass by. Occasionally, those operating the cheaper houseboats or selling the less expensive items would come in my direction, but the salesmen with high priced carpets, shawls, and furs took no notice of me. Kashmir had become indeed a very peaceful place, and I was delighted. I went around in this fashion for about a week, but after awhile I noticed an inexplicable change in my outlook. Something was missing. Life was too quiet, too lonesome. I actually recalled with nostalgia the times only a week earlier when I had been so beset by these peddlers. At first I did not understand why my attitude should change, but then realized that being chased through the streets and over the water was a game of sorts and that I had, in fact, rather enjoyed it. I began to feel the same nostalgia for the merchants that I might feel for a former playmate. These street salesmen are an integral part of the Kashmir experience. The traveler may take considerable pleasure in dealing with these salesman, playing the game of each trying to outwit the other—one demanding ten times the price, the other trying to buy for half the actual value. This give and take with the merchants also helps relieve the loneliness of travel. Travel in Kashmir would not be the same without these peddlers, just as it would not be the same without the beauties.

Beauties are found on land as well as on the water in Kashmir.

A walk one afternoon took me past a Hindu wedding party and gave me a chance glimpse into one of the most important ceremonial events in a Kashmiri's life.

Along with funerals, Hindu weddings tend to be very elaborate occasions. They vary according to local custom and the wealth of the family, but can last anywhere from three to ten days. All relatives, friends and acquaintances of the same caste are invited. The bride's family expects to house and feed the out-of-town guests. Liquor, meat, fish, poultry, and eggs are all prohibited, so the wedding banquet consists of curried vegetables and sweets. During the ceremony, the bride and groom exchange wreaths, and the groom then takes the hem of his bride's gown and leads her seven times around the fire, chanting the vows seven times.

Muslims may marry only those who embrace the same faith, and in Kashmir, marriage tends to be between people from the same village. An auspicious day is chosen with the help of a fortune-teller. The ceremony is usually held in the evening and is short, lasting only ten to fifteen minutes. The reception, however, may last late into the night. The bride takes with her to her new home all necessary household utensils as well as the jewelry which is a traditional part of every bride's dowry.

Since my first visit, I have made three more visits to Kashmir and would like to offer some suggestions on choice of suitable lodging. Before the tourist can set out to enjoy the various pleasures of Kashmir, the first step must be, quite obviously, to decide where to stay. The first-time visitor may find this a surprisingly difficult decision. There are two types of overnight facilities: hotels and houseboats. After the long trip to Kashmir, it would be rather exhausting to wander about with suitcase in hand looking for a hotel. Also, one would be surrounded by the many hawkers and too tired to enjoy viewing their wares or

bargaining with them. Lodgings come first.

On my first trip to Kashmir, I went straight to the government operated Tourist Reception Center which is located conveniently for both the long-distance buses and those arriving from the airport. Here at the Reception Center are a post office, an Indian Airlines office, and offices for the Director of Tourism and the Director of Fisheries. The Houseboat Owners Association and the Hotel Association have offices here too. There are also booking offices for sight-seeing and excursion buses. From the Reception Center I could decide on a suitable hotel and book a room for one night. On subsequent trips I have also stayed in the lodging facilities (32 rooms) adjacent to the Reception Center. To be completely certain, it would be wise to book a room for a day or so prior to setting out for Kashmir. Then after arrival, more time can be spent considering the most desirable type of lodging for the rest of the visit.

Srinagar is famous for its houseboats, and nearly every visitor wants to have the exprience of staying on one. It is an excellent way to get a real feel for Kashmir. Deciding which kind of houseboat, however, can be a confusing proposition. There are A, B, and C class houseboats, and the facilities as well as the locations are quite varied. Some face an open lake. Some are on a quiet canal, and others might be on rivers which are not always very clean. Before making a decision, it is better to engage a *shikara* and go have a look for oneself. In one of these little boats you can wander the lakes, canals, and rivers until you see a houseboat which strikes your fancy and inquire about prices and food. After inquiring at four or five houseboats, you will surely find one which appeals to you, and in the process you will enjoy your tour of the waterways.

In addition to considering the location, facilities and price, there is one more factor to keep in mind when deciding whether

to stay on a particular houseboat. In the short time you are being shown around, you must try to determine the personalities of the owner and the people working for him. The relationship between guest and proprietor is quite different on a houseboat from at a hotel. No matter how many days you stay at a hotel, it is possible to keep to yourself, but after about three days on a houseboat, the visitor begins to feel like an old friend. The lengthier the stay, the more like a member of the family the visitor grows. On the smaller houseboats, lodgers even eat with the owner and his family, which increases the intimacy. The advantages to staying on a houseboat lie in having the opportunity to enjoy quite unusual overnight accommodations in addition to getting personally acquainted with the people of Kashmir and their families. The proprietor and his family may have a separate boat attached to the main houseboat, but the visitor still gets to know them quite well. Usually, no help is hired from outside the family. On my boat, for instance, the owner's wife did all the cooking, and the younger son cleaned the rooms. The houseboat provides an excellent opportunity indeed for those tourists whose purpose it is to mingle with the local people and learn about a different style of life.

One friend stayed on a houseboat for three weeks and in that time learned ten different varieties of authentic Kashmir cuisine. The houseboat served as a cooking school for her. I was once on a houseboat for almost a month. The owner's youngest child—a little girl of five—became very attached to me. The night before I left I remember having a very serious conversation with her father on how I could best leave without hurting her.

The personal relationships forged with the houseboat owners and their families play a major role in shaping one's impressions of Kashmir. So the traveler deciding to stay on a houseboat is advised to exercise extreme care in judging the character of the

proprietor and his family. If you correctly judge them to be good people, your stay in Kashmir will be all the more pleasant. If not, you may have a rather uncomfortable time. The first time I stayed on a B-class houseboat, the owner was constantly trying to sell me souvenirs or arrange guided tours to outlying areas for exorbitant fees.

There is one more feature to consider when deciding whether or not to stay on a houseboat. A houseboat is separated from land and if the visitor wishes to go shopping or take a walk there is no way to go but by small boat. All the houseboats have one or two boats to be used for this purpose and if you have planned an outing there is no problem getting to shore. If you suddenly feel in the mood for a short walk, however, you may not always find a boat available. You are not, then, as free to wander aimlessly as you would be if you were staying in a hotel. To be sure of having a boat free to transport you, you must be willing to decide ahead of time whether to stay on the boat or go out on the town. If you like a quiet atmosphere and enjoy being on water, though, you will probably be happiest on a houseboat. This is particularly true for those who like fishing, water-skiing, and other water sports.

One's general preferences are important, but the interests of a traveler can be capricious, and it sometimes happens that after you decide on a hotel you think you should have tried a house-boat, or after you are on a houseboat for awhile you begin to long for the hustle and bustle of the city. I usually try to avoid making any long commitment and leave myself free to change.

One of the most pleasant pastimes for the traveler to Kashmir is taking short trips out of Srinagar into the countryside. Every guide book on Kashmir describes the beautiful green mountains and picturesque valleys where visitors can completely relax and enjoy the clear bracing mountain air. Most of these places can be

visited by bus or taxi from Srinagar. Each takes about half a day, so the visitor should be sure to plan on a minimum of three days in Kashmir so as to allow time for trips out of the city. Detailed information is available at the Tourist Reception Center.

Many tourists engage a guide to take them by car to these out-lying areas but with proper investigation you might discover that this is unnecessary. In fact, it can be more pleasant to take in these sights on one's own. These magnificent areas are best enjoyed in silence. The beauty of mountains, flowers and rivers can be diminished by lengthy explanation and comment. Guides who feel that they must earn their fee by providing a continuous stream of information only distract the visitor from the scenes before him. I personally feel that the greatest pleasure of visiting Kashmir's scenic spots lies in quietly savoring the clear air and beautiful gifts of nature.

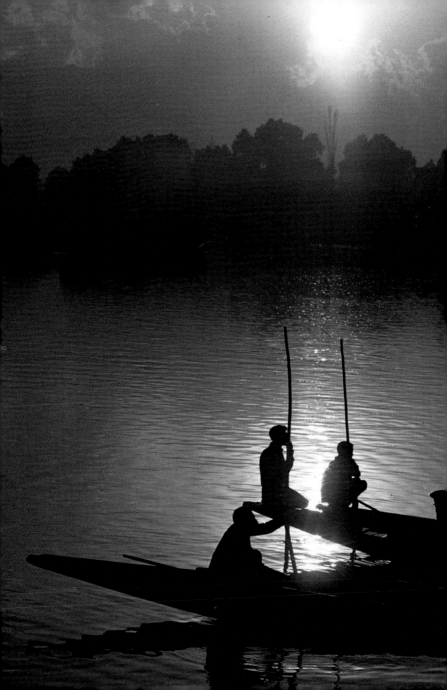

1–5. For the many people who live on the lakes, the *shikara* is an indispensable form of transportation. The preceding page shows ferrymen in their *shikara* on the Jhelum River at twilight. Even children can handle *shikara*, and a family makes its way over the waters in this boat too. Birds such as depicted in Kashmir carpets fly off as boats approach.

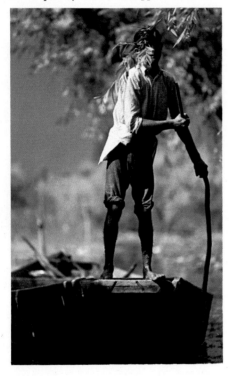

6. In the shadow of towering mountains, a▷ *shikara* is sculled along the north side of Lake Nagin.

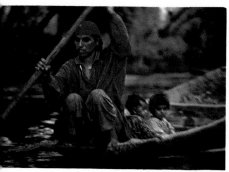

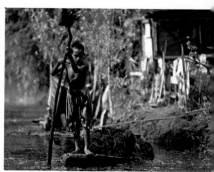

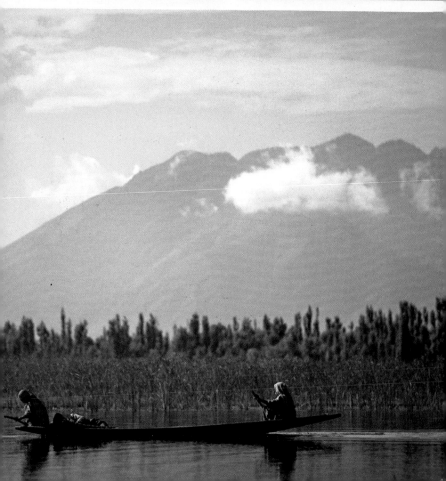

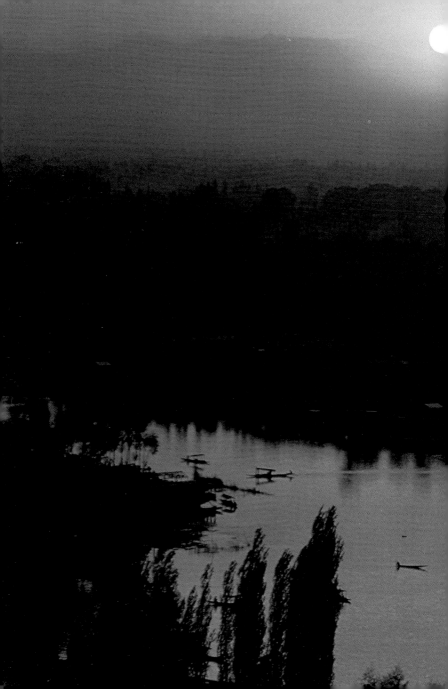

◁7. Preceding page: A view of Lake
Dal and the Jhelum River.

8. Above: A Kashmir carpet. 9. Below: View of
Srinagar, which is particularly beautiful when seen
through the fog of daybreak or nightfall. 10.
Above center: Houseboat at dusk. 11. Upper
right: Moorings on Lake Dal in evening light.
12. Lower right: The Jhelum River as it flows into
Lake Dal.

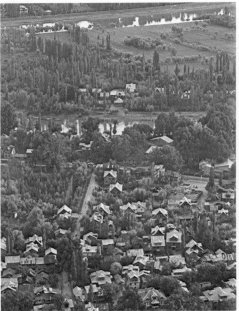

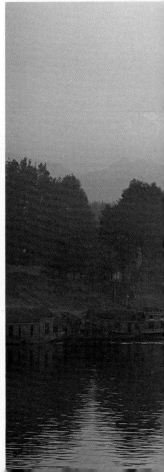

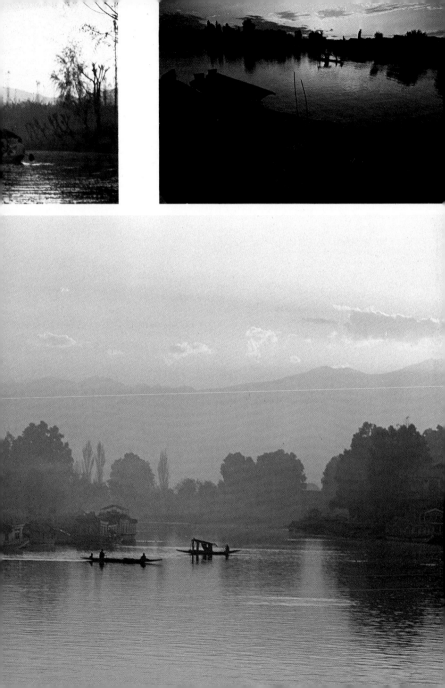

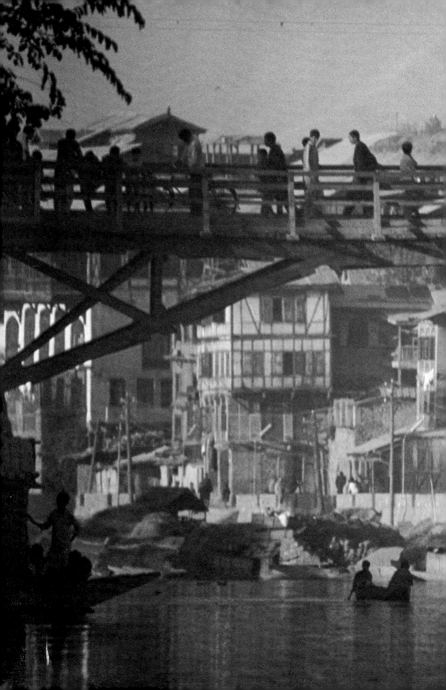

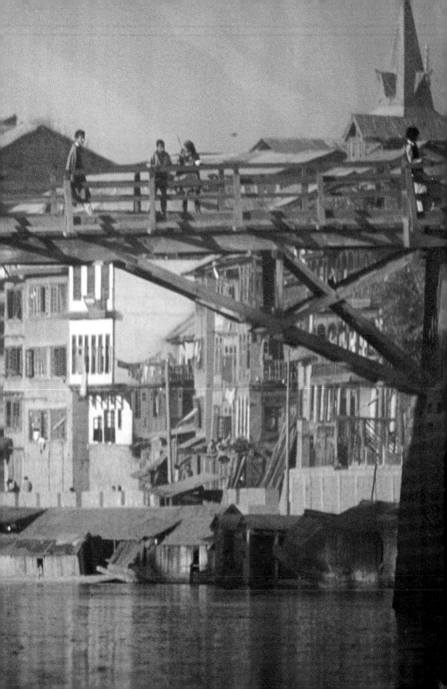

◁13. Preceding page: One of the nine bridges over the Jhelum River in Srinagar. Taking a *shikara* along the river is a good way to observe everyday life.

14. Children often gather to feed the many ducks.

15–16. Women doing wash. For women, the water's edge is a social gathering spot, and for children a place to swim and play during the short summer season.

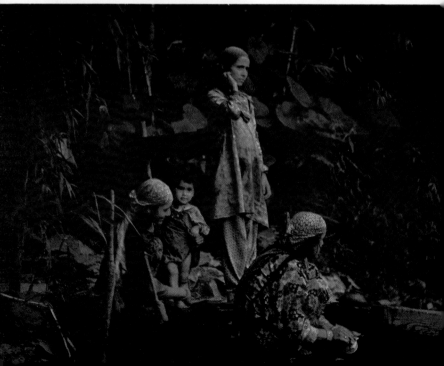

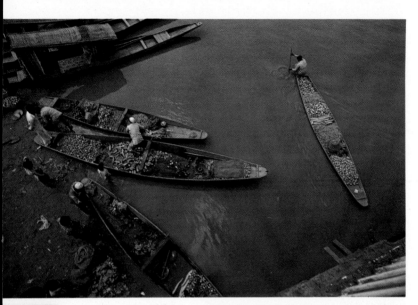

17. Produce being delivered from the floating gardens to the boat landing on the river near the center of Srinagar.

18. Child in the window of a house at the water's edge.

19. Overleaf: Brick houses along the river. The houses on the water's edge are shops, and customers arrive by *shikara*.

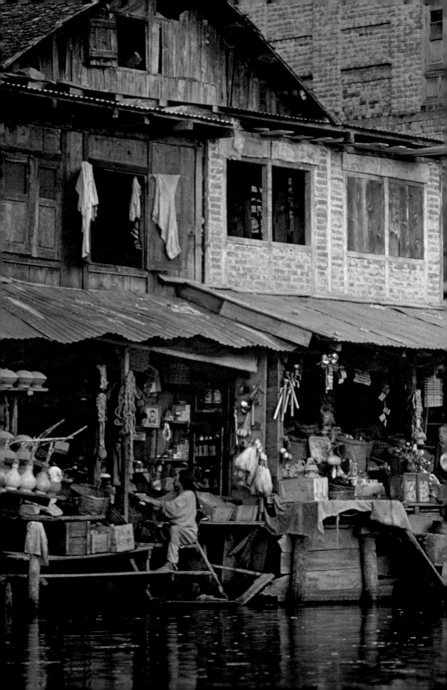

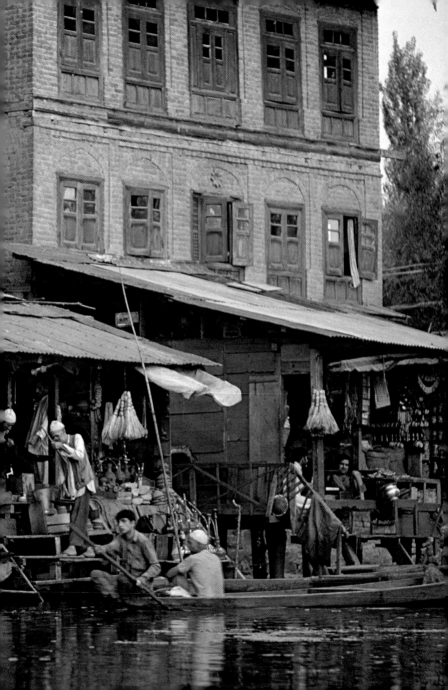

20–21. Houseboats range from the very elaborate (below) to the very cheap (lower left).
22–25. Some houseboats have verandahs for relaxing and sunbathing, sumptuous dining rooms, bedrooms and living rooms. The A-class boats all have kitchens and baths. The furniture and interior as well as exterior paneling often bear the famous Kashmir wood carving.
26. Overleaf: Lotuses on Lake Dal as seen from the cushioned, draped interior of a *shikara*.

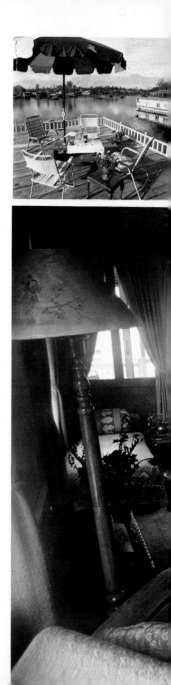

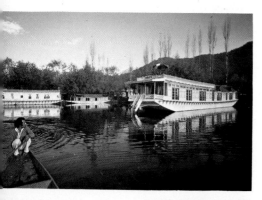

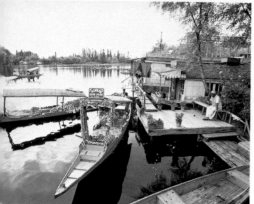

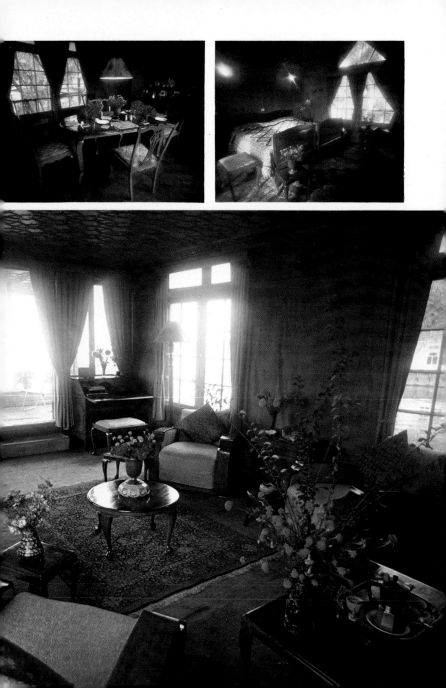

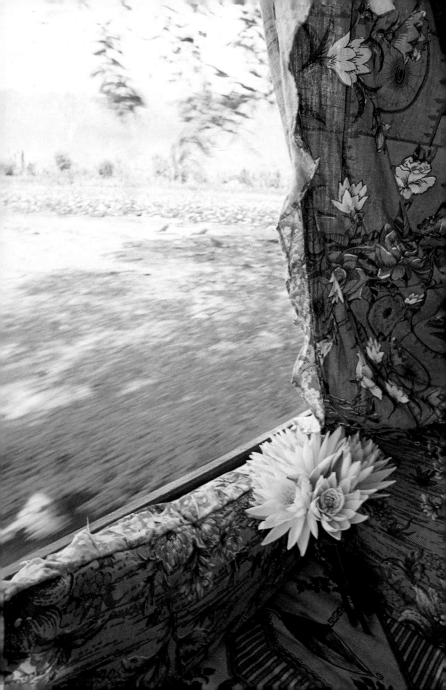

The Riches of Kashmir

The State of Jammu Kashmir (commonly called Kashmir) is the northernmost of India's states. With an area of about 223,000 square kilometers, it is just slightly smaller than the United Kingdom. Its total population is approximately 5,700,000 and may be grouped culturally into three distinct areas which correspond to the three provinces: the Vale of Kashmir, Jammu, and Ladakh.

Srinagar is the capitol of Kashmir during the summer season. Because of heavy snowfall, the capitol moves 293 kilometers south to the city of Jammu for the winter months. This city (elevation 305 m.) is situated between Srinagar and Pathankot, the terminus of India's Northern Railway. The only route into Kashmir by land begins here at Pathankot, and Jammu affords a convenient stopping place for travelers on the way to Srinagar.

The Vale of Kashmir is a deep basin lying between the Central Himalayan and the Pir Panjal mountain ranges. Its average elevation is about 1,600 meters. Through it serenely flows the Jhelum River, a tributary of the great Indus. To the north is the Karakoram Range (meaning "Roof of the World") where some of the highest mountains in the world may be found. Mt. Godwin Austen (8,611 m.) is second in height and beauty only to Mt.

39

Everest. The people of this area are tall with white skin and handsome features. They are a mixture of Indian and Pakistani people.

Ladakh, in the eastern part of Kashmir, ranges in elevation from 4,000 to 5,000 meters above sea level. It is on the western edge of the Tibetan Plateau. Even today, the 100,000 people of Ladakh are mostly of Tibetan stock and maintain Tibetan cultural patterns. There is very little rainfall in Ladakh and because of the high elevation, people living there must endure very harsh natural conditions: thin air, high winds and extremes of hot and cold.

Since the beginning of recorded history, Kashmir has been a part of India. In the third century B.C., King Ashoka encouraged the propagation of Buddhism through Kashmir and for the following several centuries, Buddhist and Hindu religions thrived side by side. It was during this time that many Buddhist and Hindu temples were constructed. In the year 1586, however, Kashmir was conquered by the Mughal Emperor Akbar and from that time the entire area became Muslim. Akbar's son Jahangir (1605–1627) and a later emperor, Shah Jahan (1627–1655), were greatly attracted to this area and laid out several beautiful gardens around Lake Dal in Srinagar. The name Kashmir is said to be derived from the name of the legendary sage, Kashyapa. Geological evidence corroborates the fact that what is now Kashmir was once occupied by a vast lake. The legend has it that this lake was inhabited by an evil demon, but that Kashyapa cut through the mountains and drained the lake, thus vanquishing the demon and making the area habitable.

To this day Kashmir is blessed with soaring high mountains, emerald green lakes, flower-covered steppes, year round snow, alpine butterflies, clear streams cascading from the mountains, and lakes glistening in the evening sun. She has caves, springs,

waterfalls, thick green trees, and plentiful fruits: apricots, cherries, apples, peaches, plums, nuts, and almonds. She abounds in a variety of fish, animals, and wild birds. In spring the mountains and fields are covered with bluebells, daffodils, narcissus, pink and white almond blossoms, deep red poppies, and many varieties of iris.

These are just some of the features which cause Kashmir to be called "a jewel set in the mountains," "a paradise on earth." This fabulous natural setting offers a year-round sports paradise as well—a visitor may at different times enjoy mountain climbing, hiking, trekking, outings by pony, skiing, camping and hunting trips, tennis and golf, boating, fishing, swimming, and water-skiing.

SEASONS

The spring months of March and April are cold and windy but the trees are laden with blossoms. In May and June the weather is quite pleasant and this is one of the the best times to visit Kashmir. Between June and the end of August it is unpleasantly hot. Most visitors leave Srinagar for such cooler spots as Gulmarg, Pahalgam, or Sonamarg.

By the end of August, tourists again flock to Srinagar for shopping and visiting the many scenic spots in and around the valley. Autumn is clear and cool, the most pleasant season of all. Saffron plants bloom in November as the trees begin to change color.

Snow usually starts to fall around the end of December and the mountains are covered by January or February. Even the lower areas of the valley always have at least 30 cm. of snow. The route from Jammu over Banihal Pass is blocked the entire winter due to heavy snows and the route from Rawalpindi is also usually

blocked for a short period.

The average annual rainfall in Kashmir is less than in other areas of the Himalayas. In Srinagar it never exceeds 68 cm. Monsoons come in July and August but the Pir Panjal Mountain Range prevents much rain from reaching the interior of Kashmir, where actual rainfall is very scant. It is generally only about 25 cm. at Dras and 10 cm. at Led. There are frequent thunderstorms and rainfall from June to August. These can be quite heavy although there are intermittent periods of sunshine. The valley experiences occasional earthquakes of light intensity.

Recommended clothing:

> Spring—medium weight clothes and warm overcoat
> Summer—summer clothes and light wool sweater or coat
> Autumn—light wool clothes and overcoat
> Winter—heavy wool clothes and warm overcoat

For mountain climbing, hiking, trekking, and skiing, it is essential to come prepared with one's own equipment and adequate clothing. It is also necessary to bring bedding unless staying in an A-class hotel or houseboat.

ROUTES TO KASHMIR

By air: During the tourist season, Indian Airlines has daily special flights direct from Delhi. The distance to Srinagar is 773 km., the flying time two hours. Three times a day, there are also flights from Delhi via Amristar and Jammu or through Chandigarh, Amristar, and Jammu. Stopping at each airport along the way is a good way to view the mountains, but the trip will take about six hours. After arriving in Srinagar, the center of the city can be reached by bus or taxi in about 20 minutes.

By rail: Daily rail service is available from Delhi, Bombay

and Calcutta to the Northern Railway terminus at Jammu. Some, but not all, of the carriages are equipped with air conditioning. To continue north from Pathankot to Srinagar, the visitor must either fly or take a bus. The bus route is 400 km. and will take one whole day by 8-passenger station wagon, or a day and half by 21-passenger bus. En route, overnight facilities are available at Jammu, Batote, or Banibal.

By bus, car, or taxi: If ample time is available, it is well worth driving the entire distance to Srinagar. The roads are excellent and the scenery en route is magnificent. If you leave Delhi early in the morning you will be able to make the 390 km. drive to Jullandur by noon. Here, you can have lunch and relax a few hours while avoiding the hot midday sun. From here you continue on another 224 km. north, through the town of Pathankot to Jammu. Jammu is the ideal place to stop for the night. It is a large city with a hospital, post office, and telegraph office. There are western-style hotels as well as the Indian-style, government-run Dak Bungalow. The next day's drive on to Srinagar is 293 km. and takes about eight to ten hours. The road goes over the famous Banihal Pass and will vary in elevation from 365 to as high as 2,286 meters above sea level.

GUIDE TO SRINAGAR

The city: This summer capitol is at an elevation of about 1,700 meters and covers an area of approximately 30 square kilometers. The population is about 320,000. The Jhelum River flows through the town and at nine points bridges span this beautiful river. It is lined with characteristic Kashmir-style houses. The roofs of these houses are made of earth, and blossom into lush rooftop gardens every spring.

The main lakes are Dal and Nagin, and innumerable canals flow

outward from them. All of these waterways are bustling with houseboats, *shikaras* and boats on which whole families may live. In the town itself there are many cars, buses, taxis, and one other form of transport for hire—the *tonga*, a horsedrawn carriage. All through the town are temples, mosques, people in native dress, and open-air stalls which serve to remind the visitor of Kashmir's past.

Lakes: Lake Dal is a beautiful spring fed lake in the eastern part of the city at the foot of Mt. Shridhara. It is approximately 8 km. long and 5 km. wide and is dotted with islands and floating gardens. It is an ideal place to moor a houseboat, or to go for a picnic or outing by *shikara*.

Lake Nagin is separated from Lake Dal by a causeway and is much smaller in size, but is one of the loveliest lakes in Kashmir. Its name means "Jewel in a Ring." The water is deep and blue and it is encircled by a ring of green trees, thus giving the place the appearance of a sapphire in an emerald setting. There is a club at Lake Nagin which offers water-skiing, swimming, and sailing.

Gardens: The Mughals (the former Mongolian conquerors of India) were great lovers of gardens, and many of the famous gardens in Kashmir may be attributed to them. Akbar, who initially brought Kashmir under Mughal rule, found the area similar to his homeland and laid out one of the original gardens. A later Mughal emperor named Jahangir and his artistic queen, Nur Jahan, were particularly gifted in the art of garden design.

CHASMA SHAHI is the smallest of the Mughal gardens and is the closest to town (8 km. from Srinagar). Its name means "The Royal Spring" and the ice-cold water from the spring is reputedly embued with excellent medicinal properties. It was established during the reign of Shah Jahan (1627–1655) and is beautifully located with a view of Lake Dal and the surrounding hills. There is a restaurant at this garden as well as tourist cabins.

Just ten minutes out on the lake from here by *shikara* is a lovely little island called CHAR CHINAR. The word *char* means "four," and there are four large *chinar* trees on this island, giving it its name.

NISHAT BAGH is 11 km. from Srinagar, just a few kilometers beyond Chasma Shahi. Its name means "Garden of Bliss." Laid out in 1663 by Asaf Khan, the brother of Queen Nur Jahan, this garden is right on the bank of Lake Dal and may be reached by boat from Srinagar. It is the largest of the Mughal gardens and was planned with twelve terraces, one for each of the signs of the zodiac. Cascading down through these terraces is a channel of water which supplies the many fountains. The top terrace affords a magnificent view of the lake and surrounding mountains.

SHALIMAR BAGH is 15 km. northeast of Srinagar, just beyond Nishat Bagh and somewhat similar to it in design. Its name means "Abode of Love" and it was laid out in 1619 by the Emperor Jahangir for his queen Nur Jahan. There are four terraces with many pools and waterfalls. The water runs down to the lake in a canal lined with *chinar* trees. On the first terrace is a pavilion which was used for public audiences. Private meetings took place in a pavilion on the second terrace, and on the third terrace, a black marble pavilion surrounded by fountains was reserved for the use of the harem. The fourth and by far the most beautiful terrace was originally the area where the queen and her ladies resided.

NASSEM BAGH is about 5 km. from Shalimar Bagh around on the other side of the lake facing east. It is the oldest of the gardens, having been planned by the Emperor Akbar, and its name means "Garden of the Morning Breeze." Even though there are no streams, fountains, or flower beds, its many *chinar* trees give the garden great tranquil beauty.

Historic Sites: The ruins of HARI PARABAT are located high on a hill in the northeastern section of Srinagar and can be seen from quite a distance The castle was constructed by Atta Mohammed Khan, an Afghan who governed the area until 1776. The walls surrounding the castle are from an earlier period, however, having been built by Akbar between 1592 and 1598. At the base of these walls on the southern side is the grave of a famous Muslim sage. There are other Muslim graves in this area, all facing Mecca. Extensive almond gardens, a magnificent mass of blossoms each spring, encircle the walls.

BURZAHOM is a prehistoric site about 5 km. beyond the Shalimar Gardens and 20 km. from the center of the city. Excavations begun here in 1960 indicate that Kashmir was inhabited as early as 2500 B.C.

HARWAN is the present site of Srinagar's water supply and is about 3.5 km. east of the Shalimar Gardens. Visitors may see the remains of ancient decorated paved roads which have been excavated and restored. Close examination of the tiles reveals evidence of Central Asian influence in dress: loose trousers, Turkoman caps, close fitting turbans, and large earrings. There is a trout hatchery at this reservoir as well as a nice garden. Tea and refreshments are available at a state-run cafeteria.

HAZRATBAL MOSQUE is an historic mosque about 10 km. north of Srinagar on the western bank of Lake Dal. It was built by Shah Jahan and is a curious mixture of Mughal and Kashmir architecture. The walls and porticos are of brick on a base of carved stone. The roof is in three tiers as is traditional in Muslim architecture in Kashmir. The mosque is an important religious site in Kashmir, as it enshrines a sacred hair of the Prophet Muhammad. This relic is displayed on special occasions such as the Prophet's birthday.

SHAH HAMADAN MOSQUE has almost become the symbol of Srinagar since it is reputedly the last wooden structure to remain from the Middle Ages. It was originally built in 1395 but was rebuilt several times, last in 1732.

JAMI MASJID MOSQUE is about 200 meters from Hari Parabat and was originally built in 1400 A.D. by the iconoclast Emperor Silcandar. It is a typical example of Indo-Saracenic architecture. The mosque was enlarged by the emperor's son, Zain-ui-Abidin, and in subsequent years was destroyed by fire and rebuilt three times. The present mosque dates from 1674.

SHANKARACHARYA is a Hindu temple standing high on a hill east of the center of Srinagar and is one of the most famous temples in the city. The site originally dates to the year 200 B.C. when Ashoka's son Jalauka first erected a temple. At a later date, a Brahman named Shankaracharya came to Kashmir to try to build up the Hindu faith, which had been undermined by the advent of Buddhism. He took refuge on this hill and it came to bear his name. Then in the eighth century, a large stone temple dedicated to Siva was built on the site.

TRANSPORTATION

Taxi: There are many taxi stands in Srinagar and taxis may also be ordered by telephone. All taxis have meters so the visitor need not worry about being overcharged. If you wish to go some distance out of the city, however, it is advisable to settle the fare in advance or you run the risk of paying for the return even if you do not ride back. If you plan to use a taxi for sight-seeing, be prepared to pay a waiting fee.

Three-wheeled scooter: These scooters have meters and operate like taxis, but charge only about half as much. They accommodate two passengers and are able to go through quite

narrow streets. They are limited in number, however, and are not comfortable for an extended ride.

Bus: Using a bus will cost the visitor only a fraction of the taxi fare but the bus stops are sometimes difficult to locate. Getting to one's destination requires considerably more time by bus, and the drivers do not understand English. There are also minibuses which are patronized mostly by students and commuters.

Long-distance buses depart from the Tourist Reception Center and seats may be booked in advance. 50 kilograms of baggage may be taken for no extra charge, but since space inside the bus is cramped, it must be loaded on the roof. The roads to Ladakh and other mountainous areas are very steep and it is advisable to take an A-class bus. The government of Kashmir also operates sight-seeing buses. These depart from the Tourist Reception Center but their schedules and fares are changeable, and it is best to inquire before making plans.

Shikara: A *shikara* is a small boat similar in function to a private car. Nearly every household has one. They can be used for transporting goods, going shopping or getting out to the houseboats. Housewives use them for shopping and farmers load their harvested produce, wash it in the lake, and take it on to market in these small boats. *Shikara* are simple to handle and can even be managed by children, who may earn money by scooping mud and duckweed from the bottom of the lake and delivering it for use in the floating gardens. There are special *shikara* for tourists which have roofs and low cushions. You can stretch out and enjoy viewing the floating gardens and sights along the banks of the rivers and canals. In the maze of waterways *shikara* pass each other swiftly and quickly, always managing to avoid collision. They are an efficient and highly enjoyable means of transportation. If you plan to stay on a houseboat for any length of time, you may even rent a *shikara* and row it yourself.

Pony: Ponies are a pleasant and convenient means of transport up into the hills and mountains. Ponies to ride may be hired for about 100 rupees ($12.00) a day; pack ponies, which can carry up to 60 kilograms, will cost about 50 rupees. The charges vary considerably according to the route and length of trip. In order to avoid misunderstanding, it is advisable to make all arrangements in advance through the Tourist Reception Center.

Tonga: A tonga is a six-passenger horsedrawn carriage operating in the older section of Srinagar. It is rather slow but one may get on or off at any time, paying at each boarding. The rates are even more reasonable than a three-wheeled scooter.

HANDICRAFTS

For centuries the people of Kashmir have been surrounded by almost picture-book natural beauty and, with their boundless energy and patience, have through the years incorporated these natural features in the colors and designs of their many and varied crafts. A large proportion of the people of Srinagar are connected in some way with the production of handmade crafts. In fact, Srinagar could almost be called a city of crafts. Many of these crafts are exported all over the world.

Wood carving: One of the oldest and most important of Kashmir's crafts is wood carving. All through the valley, walnut trees grow in abundance, and the wood from these trees is especially suited to carving and polishing. This craft's wide range of finished products includes bookends, trays, tables, cigar boxes, and lamp stands. The ancient skill of the wood-carvers may also be appreciated in the beautifully ornate ceilings of some of the houseboats.

Carpets: Kashmir's pile carpets are world famous, and in their color and design reflect a very clear Persian and Central

Asian influence. There is another kind of rug called a *numdah* which is made out of thick felt and is heavily embroidered. Using colorful cotton, wool, and silk thread, the craftsmen embroider imaginative geometrical designs and scenes from nature or ancient legends.

Embroidery: The essence of Kashmir's craftsmanship is reflected in the magnificently intricate embroidery done on silk or cotton fabric. For sale are silk saris, long coats and evening gowns, shawls, bedspreads and table linens. Of particular note are the cashmere shawls. They are very light—the highest quality shawls can be drawn through a wedding ring—yet warm and comfortable. These command extremely high prices due to the fact that they are made only from the very softest and finest fur.

Papier-mâché: One of the most distinctive of Kashmir's many handmade crafts is lacquered papier-mâché. The vivid colors used in the intricately painted lacquer are derived from stones and minerals and they never fade. Prior to application, the lacquer is heated in an unusually shaped brazier, which is also used for warming tea. The brazier's exterior is made of wicker and has a carrying handle. Inside is an unglazed pot for holding hot ashes, and the lacquer is melted over these. Craftsmen dip into the lacquer melted in these braziers to create their marvelous designs. The designs depict Kashmir's flowers, birds, fairy stories, and Muslim legends. Some of the costlier pieces use real gold leaf as well as the pigments made of finely crushed stones. Articles made from papier-mâché include bracelets and small boxes, plates and jars. Many of them are very beautiful as decorative ornaments.

Silver: Objects made out of silver are high on the list of celebrated Kashmir crafts. A special process used only in Kashmir gives the silver a beautiful white sheen. Some of the silverware is plain but much of it is engraved or filagreed. The shopper may

find delicate designs of birds, trees, and flowers.

Willow Products: Among the newest of Kashmir's crafts are products made from willow. The English willow tree is very plentiful, and some of the articles to be found are baskets, boxes, and garden furniture. Willow furniture is very light and durable.

Furs: The mountains of Kashmir are full of fur bearing animals—rabbits, bears, spotted leopards, and snow leopards abound. A wide variety of skins are brought in from the mountains for skilled Kashmiris to make into coats, jackets, hats, handbags, shoes, shawls, and rugs, all of which sell at amazingly reasonable prices. Custom-made articles may also be ordered.

Antiques: There are about five or six antique shops in Srinagar where one can find jewelry, paintings, and objets d'art. Since Kashmir for centuries lay on one of the principal north-south routes, many objects may be found which display the influence of Chinese and Central Asian culture.

Stones: There are no precious stones indigenous to Kashmir but there are many varieties of beautiful semi-precious stones. The Ladakh region, particularly, is well known for the turquoise jewelry produced there.

FOOD

A wide variety of food is available in Srinagar. Adoo's and the Grand Restaurant serve excellent Indian and Kashmir-style food, and Chinese food is available as well. The houseboats will prepare both Indian and Western-style meals for the visitor, and there are kitchens available to do one's own cooking.

The typical Kashmir meal consists of dishes made from mutton or chicken, served with rice or a somewhat hard bread. Generally speaking, the food is not as hot in Kashmir as in the rest of India. Trout from the lakes is a specialty—served either curried or fried.

Kashmir tea is a weak black tea drunk without milk, but with sugar and two or three kinds of spices and ground nuts. Its wonderful aroma lasts until the very last drop. If you like pastries, there are good, not too sweet, Western-style cakes at Adoo's.

Kashmir abounds in delicious fruits: apples, pears, grapes, apricots, strawberries, peaches, pomegranates, chestnuts and mulberries are all grown locally. Even more varieties are brought in from other parts of India. Apples are particularly plentiful and Kashmir boasts of more than one hundred varieties. One of Kashmir's unforgettable specialties is a small apple from which the core is removed and which is then filled with honey and baked. Many delicious jams are also made from the local fruit.

A variety of other products are also well known in Kashmir. In addition to rice, maize, wheat, barley and millet, abundant crops of almonds, walnuts and cashew nuts are gathered annually. The lotus honey produced in Kashmir is very thick and sweet and has its own distinctive aroma. Tea, cinchona, and hops are among the other principal products of Kashmir and the saffron, of course, is famous. Kashmir's saffron is rated on a par with Spain's and is reputed to be especially tasty and effective as an energy producing stimulant. It is so strong that it can even cause nose-bleeds if taken by children. Saffron's efficacy depends upon the quality of the blossoms, thus causing a fluctuation in price from year to year. The standard price, however, is about 20 rupees per gram (approx. $13 or $14 per pound). It is sold in pharmacies and also in the markets. A small pinch is often put in tea or used as a spice in cooking.

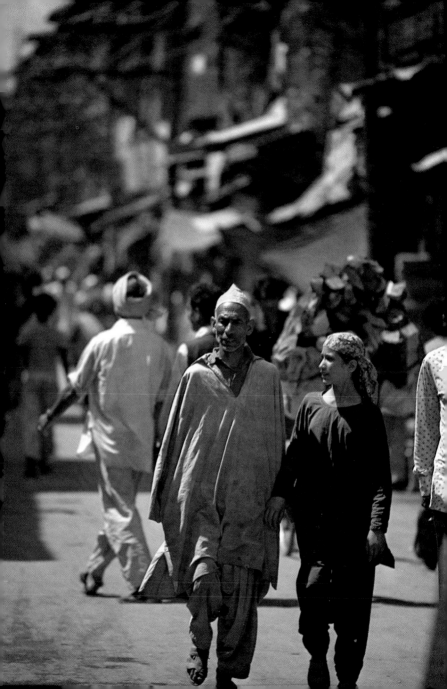

27–28. Preceding page and below: Urdu-speaking Muslims on Srinagar's narrow back streets wear layers of loose fitting garments over trousers tied at the ankles. Women wear garments embroidered around the neck and enfold themselves in scarves.

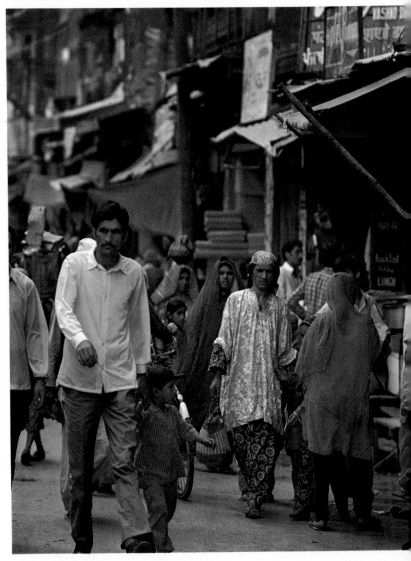

29. The back streets of Srinagar are bustling with merchants who hawk the many well-known crafts. Many use rickshaws to carry their goods. Life here appears to be carried on as it has for centuries.

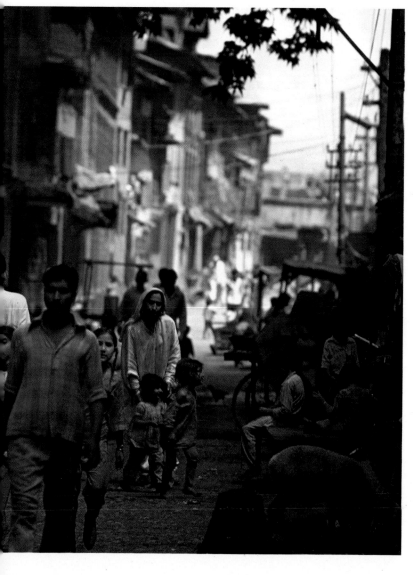

30. Strict Muslim women wear a *chador* over their heads when outside the home.

31. In Kashmir one sees brick-and-wood houses of two or three stories which are not common in the rest of India.

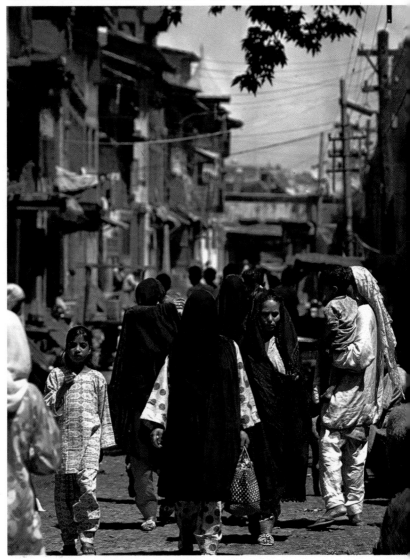

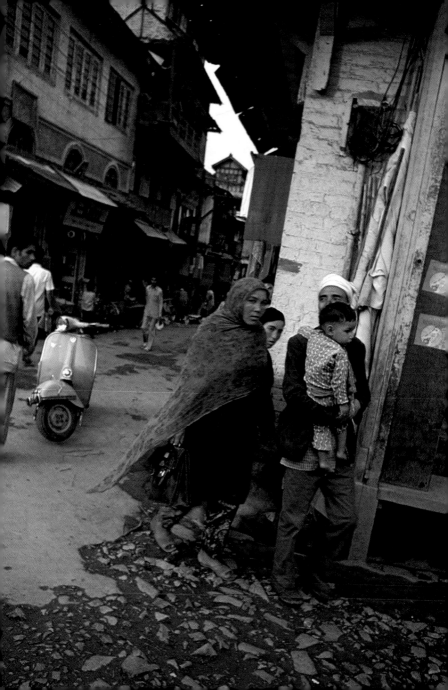

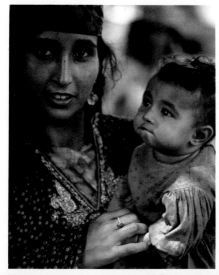

32–36. Women in Kashmir remain secluded. After marriage, they are completely subjected to the will of their husbands and devote their full time to domestic chores. Their only social contact is with other women, but gatherings can be quite lively. Only children are animated and jovial in public, and are even willing to talk to foreigners.

37. Overleaf: Taking a *tonga* back to the hotel in Srinagar at dusk. Though not apparent from the outside, the second and third stories of the houses at right are the "factories" for Kashmir's many cottage-type industries employing a few people.

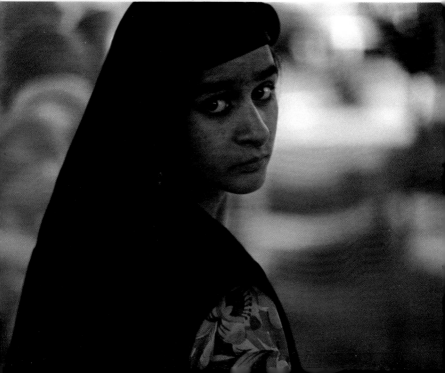

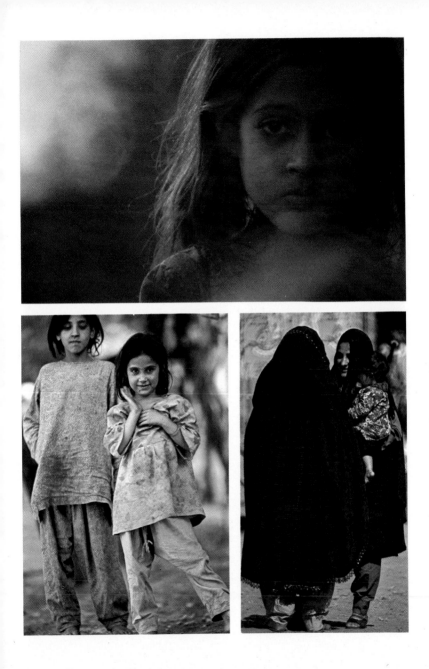

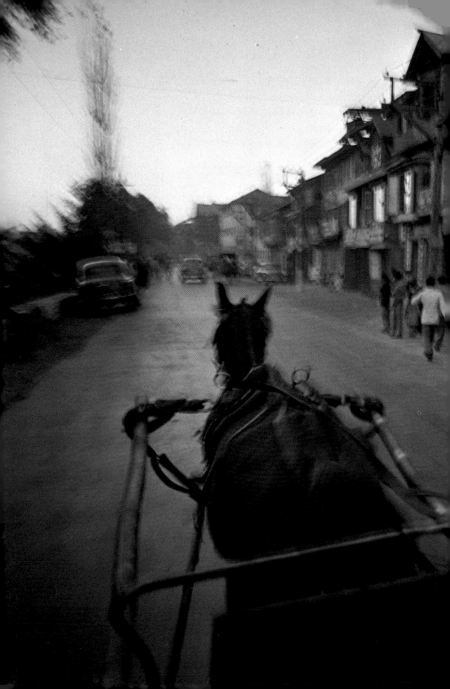

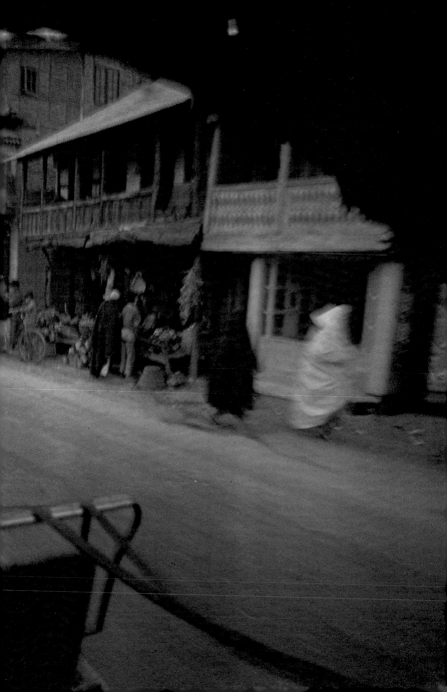

41–44. Close-ups of papier-mâché designs. 45. Lower right: Men working with papier-mâché. Every stage in making papier-mâché is done by craftsmen who specialize in one particular step. Women are occasionally seen making papier-mâché, but most artists are men.

38–40. Layer upon layer of thin pieces of paper are applied to a paper pulp mold to make the desired form of papier-mâché objects. The article is then dried, sanded, and painted after which designs, such as shown above and below, are applied in lacquer. Finally, the article is polished with varnish. Right: Some papier-mâché, such as this vase, are built up on metal forms.

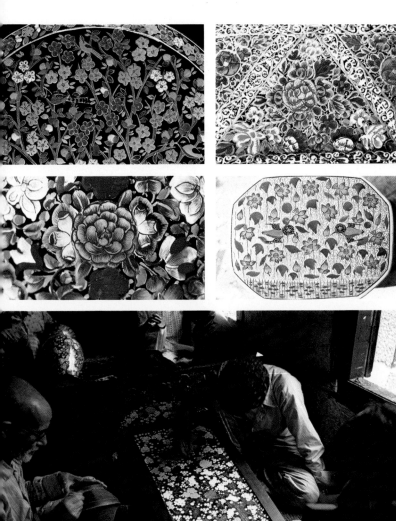

46–48. World famous Kashmir carpets. The weft threads are carefully woven one by one through the warp threads in very intricate patterns. After the weaving is completed, the carpets are thoroughly washed in water and dried in the shade. They are then laid out for sale in showrooms near the factories. In the factories, children as young as ten years old as well as old men work all day long, each on his own special phase of the process.

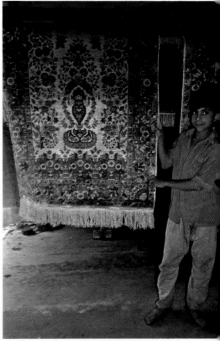

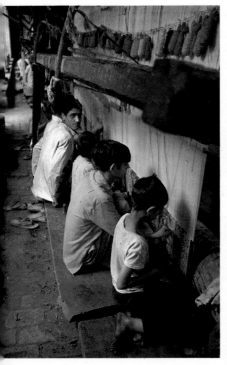

49–50. Another type of Kashmir carpet is made out of cotton cloth with wool thread. These are heavily embroidered in many colors, with a special Kashmir cross-stitch and chain-stitch. The patterns are geometrical or based on natural phenomena or Muslim legends.

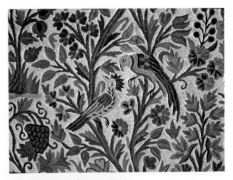

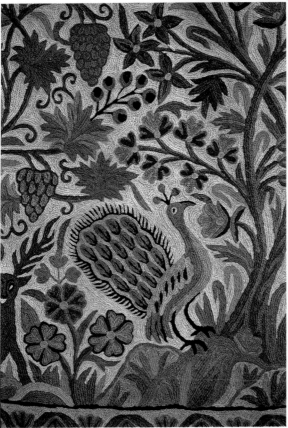

51. Kashmir's special lotus honey.

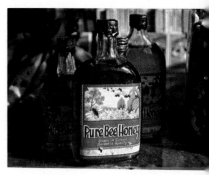

52. Cans of just a few of the many fruits grown in Kashmir.

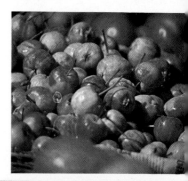

53. Produce direct from the apple orchards in the suburbs of Srinagar.

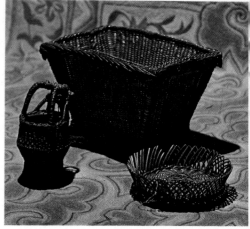

54. Well-made rattan baskets for sale at Srinagar's Central Market and Government Emporium.

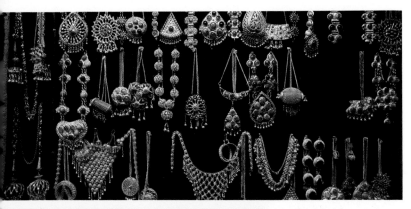

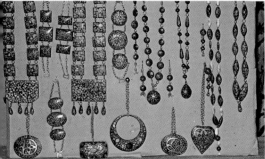

55–57. Necklaces and pendants with semi-precious stones, typical Kashmirian jewelry inlaid in blue, and engraved, filagreed metal work.

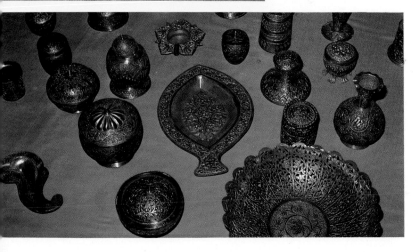

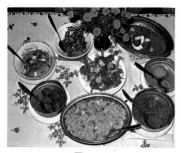

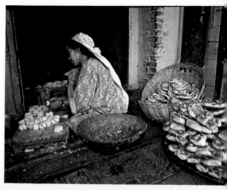

61. One of the newer shop-lined streets facing Lake Dal. People living on houseboats come to do their shopping by boat. 62. Overleaf: A grain dealer on one of Srinagar's back streets.

58. A Kashmir feast of pilaf, assorted meats (lamb, pork, beef), yogurts and curried vegetables. 59. Typical Kashmirian bread is hard but savory. 60. Baskets holding hens and cocks.

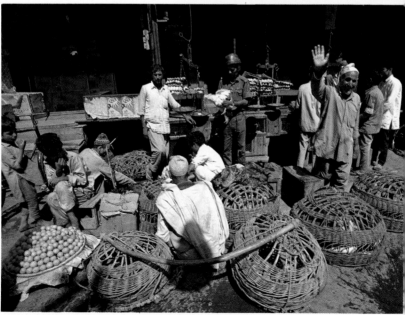

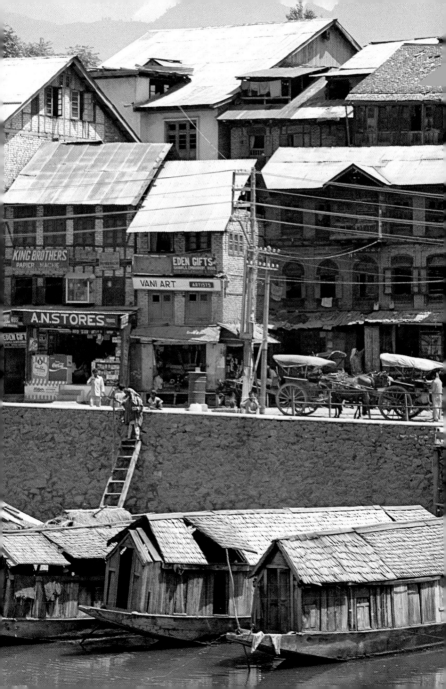

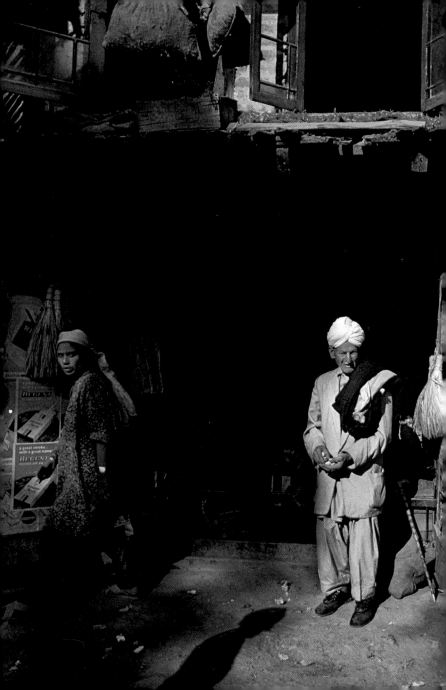

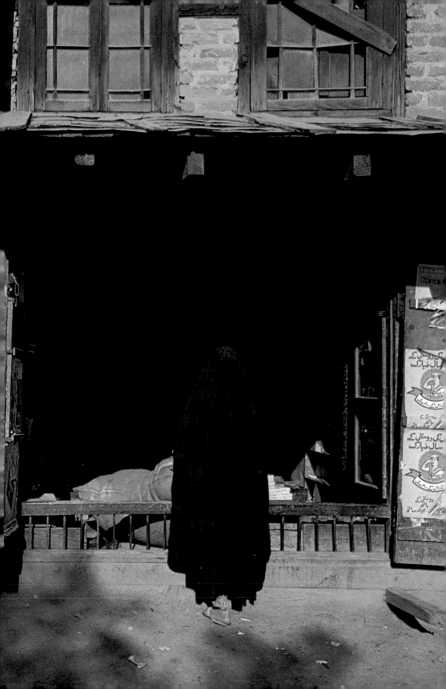

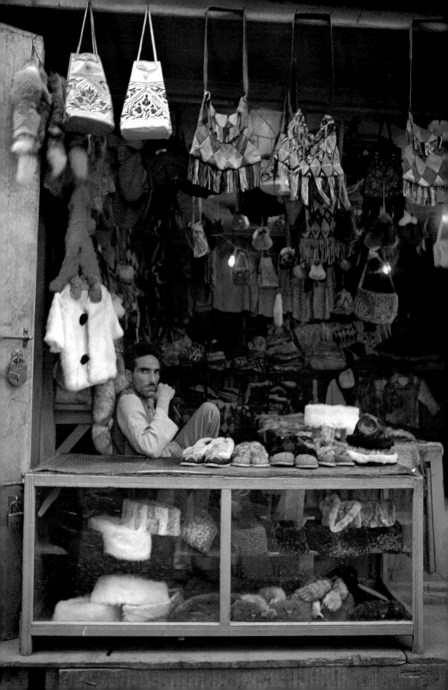

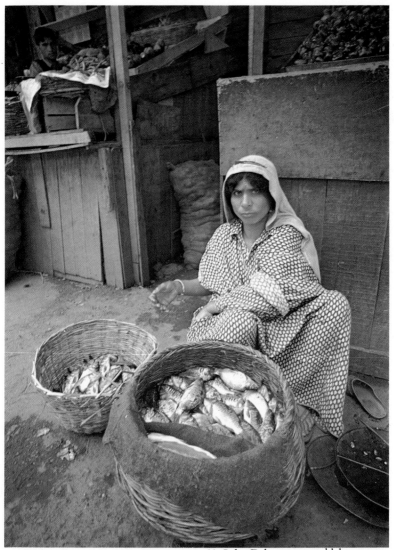

◁63. Furs and leather goods for sale. Shops like this are numerous, offering a large selection at low prices.

64. Lake Dal carp are sold by women carrying their baskets on their heads. Carp is not a common food but is served occasionally fried or curried.

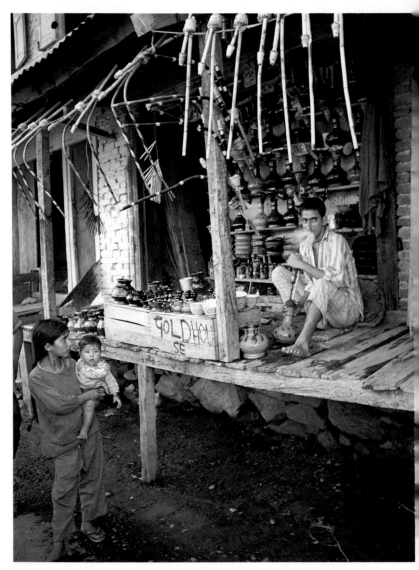

65. Simple earthenware made from a rough brick-
like clay. There is little variety of color and the
pieces are not painted. The most common items are
teapots, vases and water pipes.

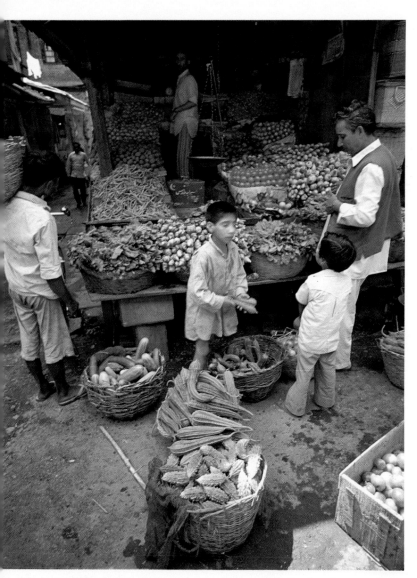

66. A vegetable market. With its four seasons and abundant water supply, Kashmir grows a wide variety of vegetables.

67. Overleaf: In the foreground are wicker-covered Kashmir braziers used to warm tea or melt lacquer for papiermâché decoration.

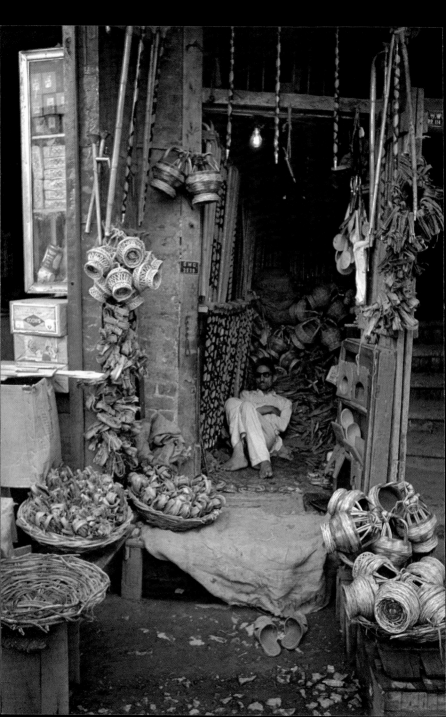

Trips from Srinagar

GULMARG

Gulmarg means "Meadow of Flowers," and as its name implies, Gulmarg abounds in many varieties of wild flowers. The Mughal Emperor Jahangir is reputed to have collected twenty-one different varieties of flowers here. At one time, Gulmarg was a summer resort for the British residents of India. Its elevation is 2,730 m. and it boasts the highest golf course in the world. The summer months of May through October are ideal for golf, riding, hiking, and picnicking. From here, the visitor has a magnificent view of Nanga Parbhat, the fifth highest mountain in the world.

The climate during the summer months is refreshingly cool and clear, and because of this excellent climate, the Indian government has established a sanitorium in Gulmarg. There is also an institute for the study of high altitude plant and animal life. The winter months are equally enjoyable. Snow covers the whole area from October to May, and many visitors come to enjoy the skiing. There are two ski-lifts.

Gulmarg is situated 51 km. east of Srinagar and may be reached by taking a car or regularly scheduled bus as far as Tonamarg (38 km.) and then walking or hiring ponies for the final 13 km. up through the pine forests to Gulmarg. Special sight-seeing buses,

however, will take you all the way through from Srinagar to Gulmarg.

Areas within reach of Gulmarg:

Khilanmarg: The village of Khilanmarg is about 4 km. uphill from Gulmarg and may be reached on foot or by pony. Here one finds magnificent forests and fields full of flowers. One also has a spectacular view of the surrounding mountains as well as Lake Wular and other lakes.

Alpather Lake: This lake (meaning "Frozen Lake") lies at the base of Mt. Apharwat (4,143 m.). It is about 13 km. up a steep but well-graded mountain path from Gulmarg. It may be reached on foot or by pony in about four or five hours. The lake remains frozen most of the year and even in summer its icy cold water is full of floating pieces of frozen ice.

Ningle Nallah: This stream is about 8 km. from Gulmarg and flows from the springs and beds of snow near Mt. Apharwat and Alpather Lake. Fishing enthusiasts may enjoy excellent trout fishing and picnickers enjoy a pleasant day at the many picturesque spots in the pine forests along this stream.

Ziarat of Babrishi: This sacred Muslim shrine is about 5 km. east of the Gulmarg valley. It is the tomb of a noted Muslim saint named Baba Pam Din who lived in this area during the time of the Mughal rulers. Both Muslims and Hindus come to make offerings at this tomb.

YUSMARG

Yusmarg is a cattle raising area deep in the Pir Panjal Mountains about 40 km. south of Srinagar. The whole valley is covered with magnificent pine trees and there are many beautiful sites for hiking and picnicking. Ponies are also available for hire, and those who wish to stay overnight may rent tourist huts. Trekking

courses start here for Lake Nil Nag and for Gulmarg via Tosa Maidan. The trek to Gulmarg takes two days. Mountain climbers may try climbing Sunset Peak (4,745 m.) or Tatakoti (4,743 m.).

LOLAB VALLEY

The Lolab Valley is to the northwest of Srinagar and may be reached by a good road beautifully lined with poplar trees. This valley is quite large (32 km. long and 6 km. wide) and is thickly forested with pine and Himalayan cedar. The visitor will also find mulberry, chestnut, apple, and pear trees. One of the main attractions in the Lolab Valley is Lake Wular. It is the largest lake in India—between 130 and 155 square km. depending on the time of year—and is one of the largest fresh water lakes in Asia. In autumn it becomes a haven for trout fishing enthusiasts and at certain times during the year many wild ducks converge on the lake to the delight of hunters. The lake is normally very placid but is sometimes swept by strong winds in the afternoon and boating can be hazardous at this time. The upper reaches of the Jhelum River flow into the lake and the river then continues south to Srinagar. A very pleasant day's trip may be made by boat down the river from Lake Wular to Srinagar. There is also a sulphur hot spring just a few kilometers northwest of the lake.

Another beautiful lake just a few kilometers away from Lake Wular is Lake Manasbal. Smaller than Wular, it is particularly beautiful with clear sparkling water and many varieties of lotus blossoms which almost cover the surface of the water near the shore.

Near Lake Manasbal is the forest site of Kheer Bhavani Shrine. This shrine is beautifully situated beside a stream and opposite it is a spring, the flow of which varies with the season and

the time of day. A big fair is held here every year from May to June.

To the northeast of Srinagar lies the beautiful Sindh Valley named for the River Sindh which winds through it. Lake Gangabal lies in this valley, 58 km. by car from Srinagar. On the way to the lake, you will pass through the town of Ganderbal where a rest house and tourist cabins are located. The town of Wayel lies 6 km. beyond Ganderbal. You will cross the river there, and another 30 minutes by car will bring you to Kangan on the shore of the lake. Trekkers and mountain climbers may stock for their trips in Kangan's many stores. At the very head of the Sindh River Valley, 83 km. from Srinagar, is the town of Sonamarg. Meaning "Meadow of Gold," this town was named for the profusion of golden colored flowers which bloom every spring. Sonamarg is a very popular camping spot and also a convenient base for trips into the mountains to the north.

The adventuresome traveler who wishes to visit Ladakh—the largest and least populated of Kashmir's three provinces—would continue east after visiting Sonamarg. There are no air flights into Ladakh; the only way to get there is by driving the 310 km. distance from Srinagar to the principle city of Leh. This takes at least two days. If one comes all the way from Srinagar, it is best to stay overnight at Kargil. Tourist cabins and rest houses are available in Kargil, but there are no good restaurants anywhere en route. One should come prepared with at least a two-day supply of food. It is also advisable to be well equipped with warm clothing. The driving is at times precarious as the road goes over two very high passes: Zojila (3,474 m.) and Fatula (4,265 m.). Many of the rocky and icy plateaus, bare of all vegetation, will

remind the visitor of a moonscape. When the road begins to follow the Indus River, the city of Leh is not far away. You should reach there by the evening of the second day. The best overnight accommodations are at the Kangri Hotel, but tourist bungalows and rooming houses are also available.

The population of Leh numbers about 4,000 and is quite different in appearance from the rest of Kashmir. From the distant past to the present day, this area has been a Buddhist stronghold and Tibetan culture is distinctly apparent in the people's religion, language, food, clothing, and housing. In the vicinity of Leh there are several Lamaist temples in which wall paintings and Buddhist statues are visible under many crusted layers of dust. Spitok-Gompa, one of the largest and most prosperous Lama temples lies about 20 minutes out of Leh in the province of Ladakh. Over 100 priests live here. Every morning and evening they gather at the top of the mountain in the large buildings which enshrine the gods. The priest's living quarters are lower down in the compound. Depending upon his wealth, a priest will occupy from one to seven rooms. The priests live alone and cook for themselves. This temple owns much of the neighboring land and rents it out to the people of the village to grow wheat and vegetables. The temple then receives a portion of the produce.

In winter the temperatures in Ladakh can fall as low as $-30°C$ and, due to the heavy snow, the road from Srinagar closes completely from November until the following May.

LIDDAR VALLEY

The Liddar Valley is due east of Srinagar and may be reached by road. It is 96 km. from Srinagar to Pahalgam. The scenery here at 2,134 m. is some of the most majestic in all of Kashmir. In

summer, Pahalgam is an ideal area for camping out in tents and enjoying the abundance of wild flowers and animals. For those who wish them, tourist cabins are also available. Pahalgam is paradise for the angler, and golf enthusiasts will enjoy the nine-hole golf course. It also provides an excellent starting point for trips within the valley. Mamlesvara is an old stone temple, about a kilometer from Pahalgam, which was constructed during the reign of King Jayasima (A.D. 1124–1149). Baisaran is a meadow about 5 km. from Pahalgam, covered with pine trees. At 2438 m. it provides an excellent panoramic view of Pahalgam and the surrounding snow-covered mountains. Lake Tulian (elevation 3,353 m.) is 11 km. from Baisaran. It takes about three or four hours to hike there from Pahalgam, but is well worth the effort. The lake is surrounded by mountains which are covered with snow almost all the year.

One of the most breathtaking trips in the Liddar Valley is to the Kolhoi Glacier. You may go on foot or by pony. It is necessary to take your own camping equipment as the trek from Pahalgam to the glacier and back will require three days. The base of this glacier is at an altitude of 1,467 m. and is the source of the Liddar River. The average tourist may enjoy exploring this lower area, but only the most experienced climbers should attempt scaling the higher reaches. Both Arau and Lidderwat are convenient stopping places on the route between Pahalgam and the glacier. They offer excellent camping sites and government rest houses. Also of interest in this area are the nomads who make their living tending goats. One should by all means try tasting the goat's milk cheese made by these nomads.

Another important attraction not to be missed in the Pahalgam area is the Amarnath Cave. It is 46 km. from Pahalgam and can only be reached on foot or by pony. A trip to the cave and back to Pahalgam requires six days, and all the arrangements for

guides, porters, and ponies may be made from Pahalgam. During the busy pilgrimage period, however, it is wise to book in advance.

Reputed to have housed the Hindu god, Siva, this cave is of great religious significance. The object worshipped here is a stalactite of ice in the shape of a lingam (a phallic symbol used in the worship of Siva). The lingam is formed by water dripping through the roof of the cave, and its size waxes and wanes with the phases of the moon. The cause of this phenomenon remains a mystery. It reaches its maximum size at full moon, and at this time thousands of pilgrims make their way to the cave.

During the pilgrimage season, the government sets up a base camp at Num Wan to assist visitors with ponies and porters, shelter, provisions, firewood, and medical aid. Due to the hazardous journey and cold weather conditions, children under twelve, the medically unfit, and those not adequately clothed for cold weather are not allowed to proceed beyond Pahalgam.

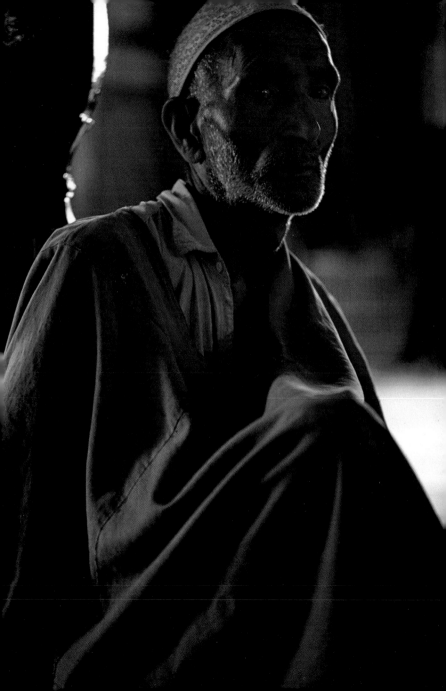

◁68. Preceding page: Old man praying at a mosque. 69. Prayer ribbons are tied on the window lattices outside mosques by women, who are not permitted inside to pray. 70. Women praying. 71. Hazratbal Mosque in the old part of Srinagar. 72. Opposite: Entrance to Shah Hamadan Mosque. 73. Overleaf: Women pray outside the Shah Hamadan Mosque.

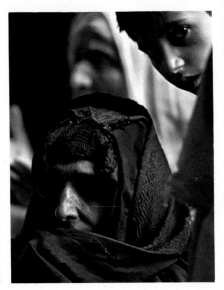

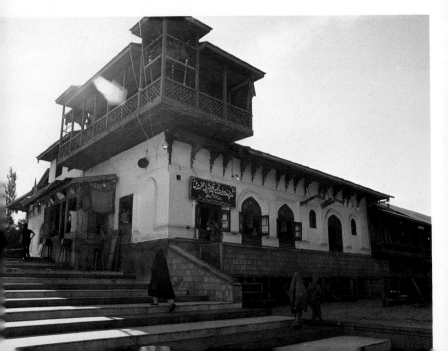

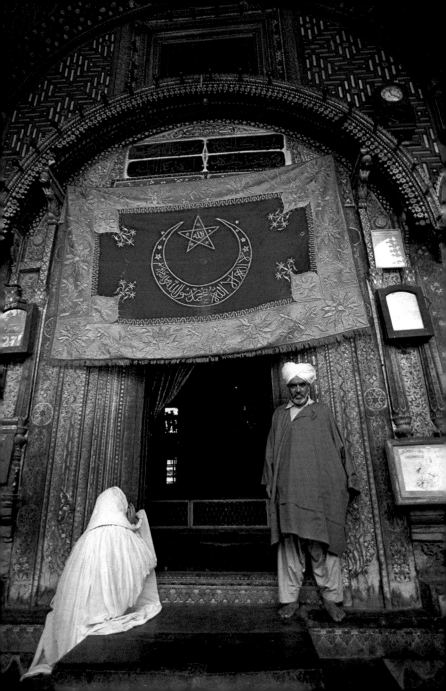

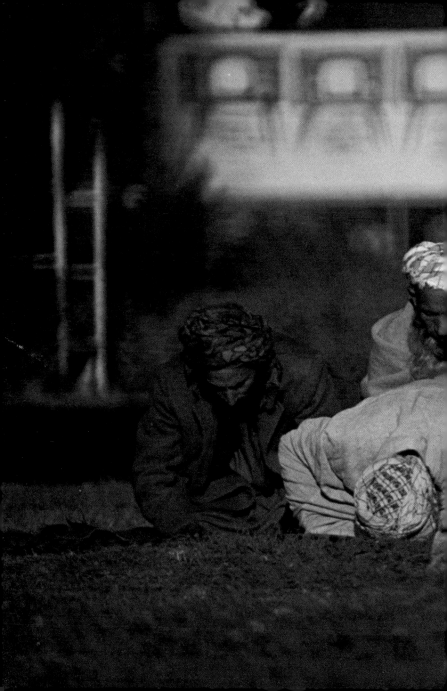

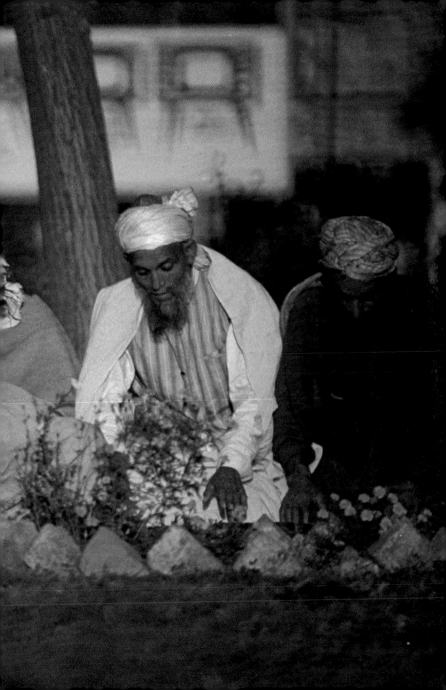

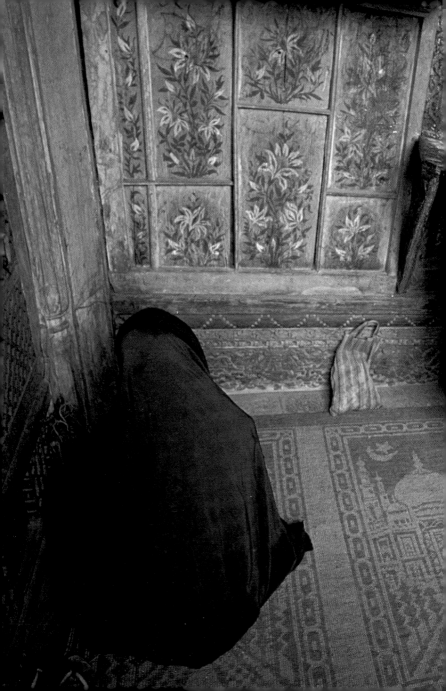

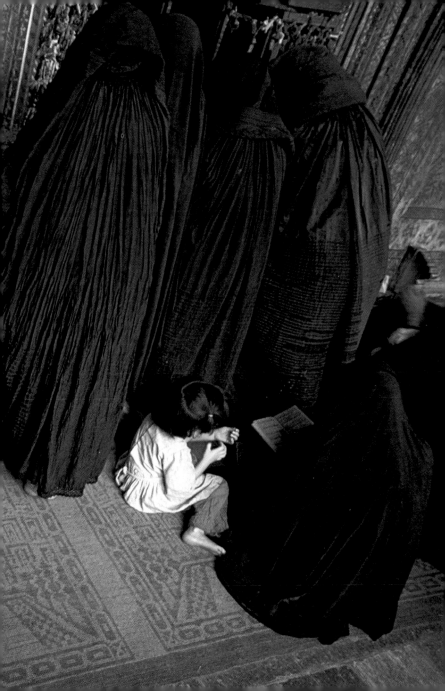

74. Preceding page: Whether at work or traveling, all Muslims stop five times a day and pray facing Mecca.
75. A bride's accessories. 76. Filagreed silver shoes. 77. Far right: After the wedding, bride and groom leave for the groom's home surrounded by women singing the parting song: "You have gone, we are sad." They sing it over and over in a monotone until the car or carriage is out of sight.

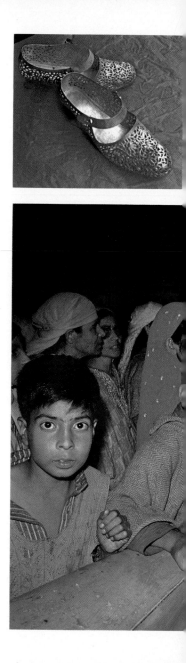

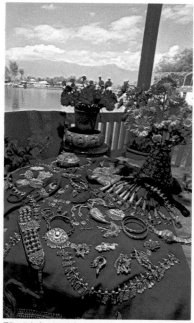

78. Right: Bride and groom are showered with flowers and coins as they leave for the groom's house.

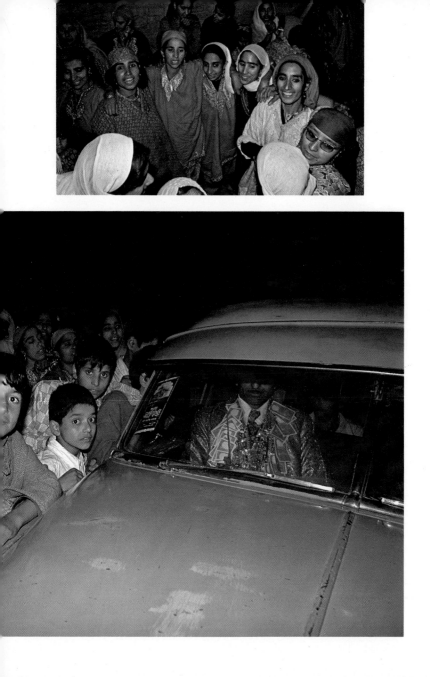

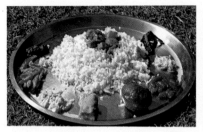

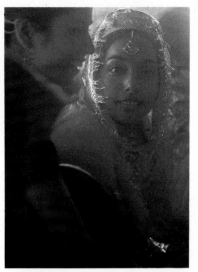

79–82. Scenes of a Hindu wedding. Above is a portion of the wedding banquet. Right are the bride and groom. The ceremony is held at the bride's home, where a priest performs the rites. Rice fried in oil, ghee, coconuts, and incense is thrown onto the sacred fire. After the ceremony, all the relatives pray for the happiness of the couple by showering them with flowers.

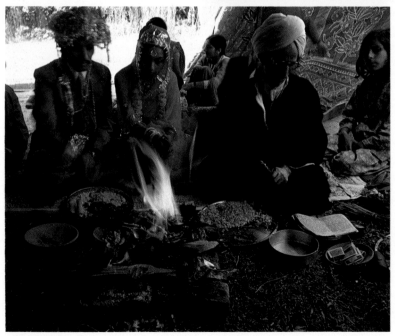

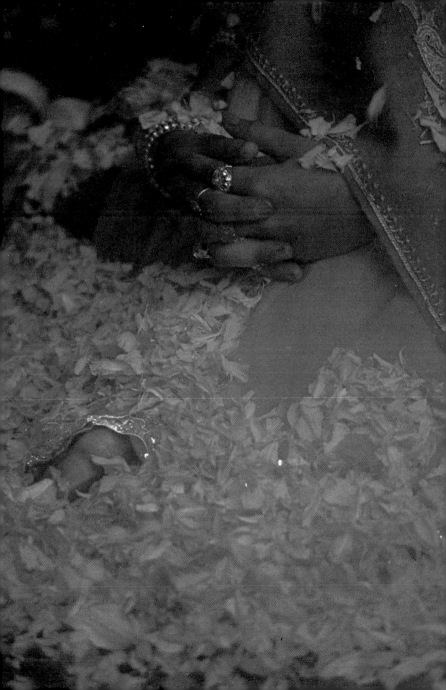

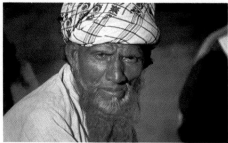

87. The women wear their hair ▷
in thin braids and wear small hats.

83. Preceding page: The countryside ablaze
with spring flowers. 84–86. Groups of nomads,
living in simple thatched huts deep in the
mountains, make their living cutting wood
and tending sheep and cattle. They occasionally
come to town for trading. Nomad men wear
turbans and often have long beards. The motif
on the rug shown here draws on a legend of
these mountain people.

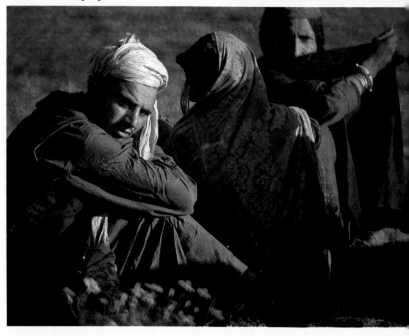

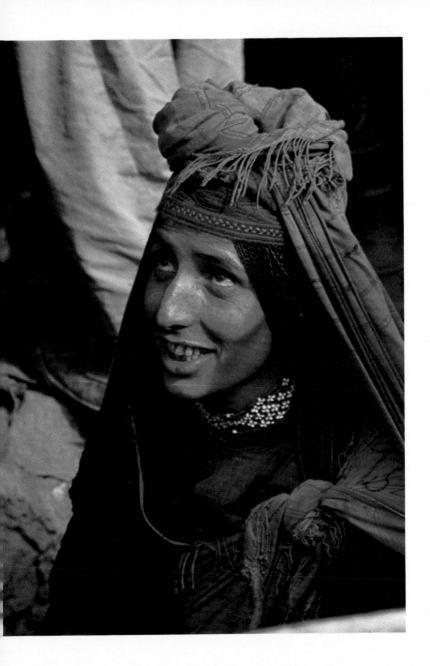

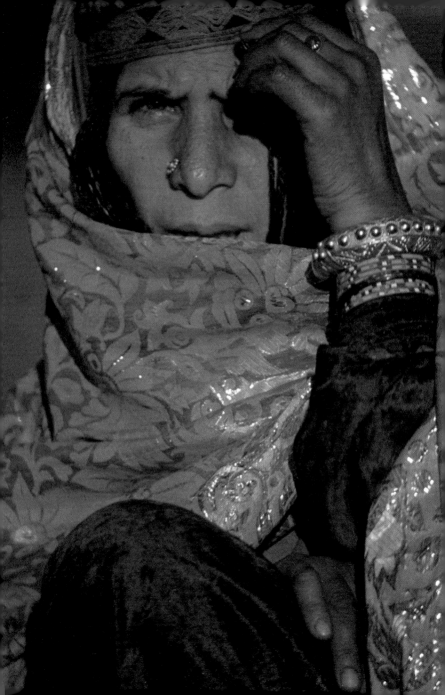

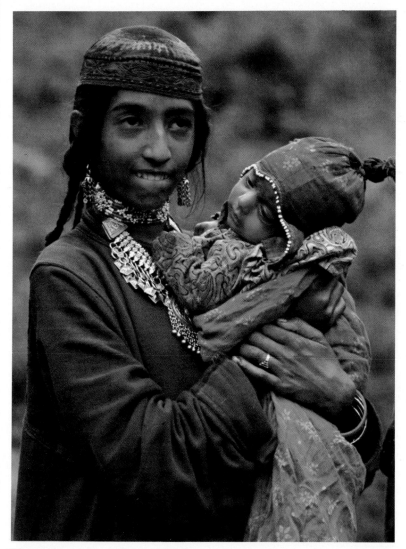

◁88. Despite their finery, mountain
women work hard tending sheep and
cattle, and making butter, cheese, and
yogurt. 89. Mountain woman and child.

90. Overleaf: Woman tending fields.
Not only men, but women, children and
grandparents share the work tending
crops.

91. Mountain animals depicted on papier-mâché.

92. When summer comes, the people living deep in the mountains will come to town by donkey or bus and trade their wares for other necessities. Here, apples are being sold on the roadside to picnickers and those returning to the mountains.

93. The road and scenery on the way to Kolhoi Glacier.

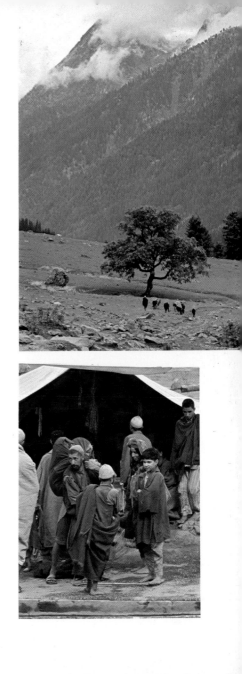

94. Mountain people selling wild animal skins in Pahalgam.

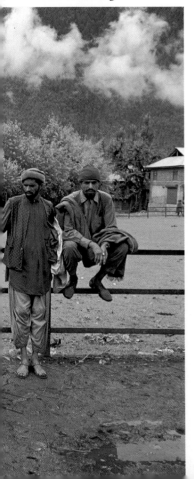

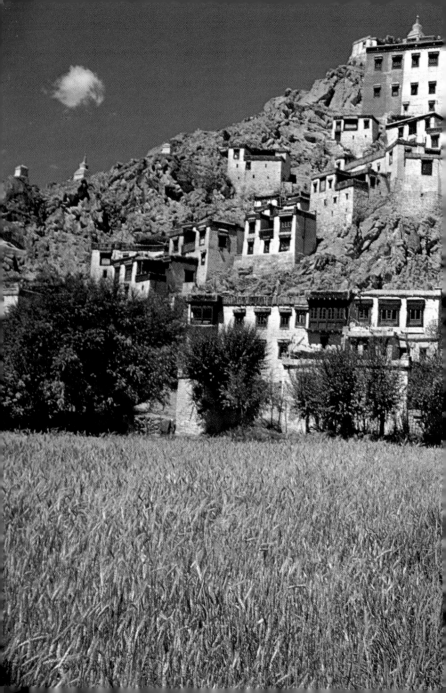

THIS BEAUTIFUL WORLD

95. Preceding page: Spitok-Gompa, one of the largest, most prosperous Lama temples, twenty minutes from Leh in Ladakh Province. Over 100 priests live here. Houses in the lower central section are the priests' living quarters.

96. Ladakh woman in formal dress. She wears a lamb's wool hat with long flaps, a family heirloom passed down from mother to daughter. These hats are sewn with turquoise, coral and old coins, and can be quite heavy.

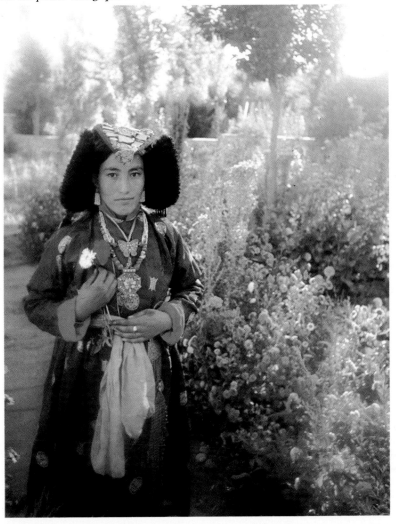

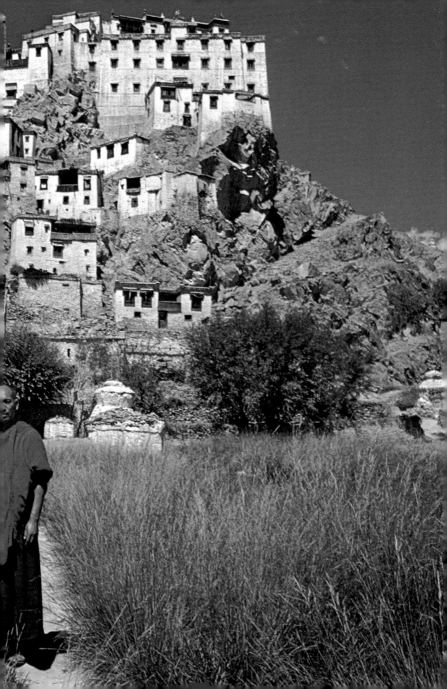

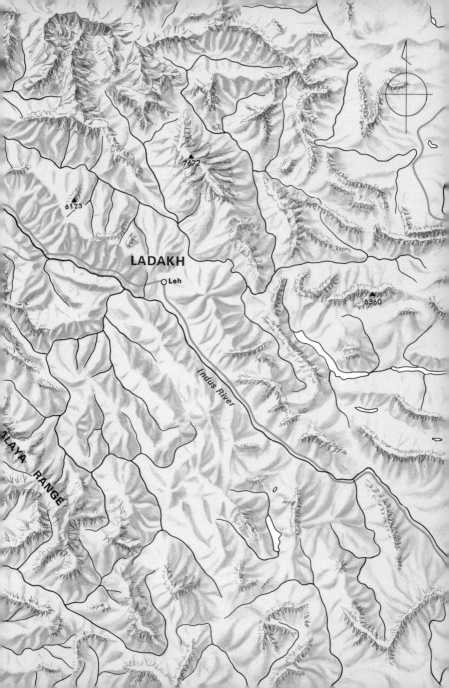